Digital

Night

and **Low-Light**

Photography

Digital Night and Low-Light Photography

TIM GARTSIDE

THOMSON

COURSE TECHNOLOGY

Professional ■ Technical ■ Reference

Contents

First published in the United States in 2006
by Thomson Course Technology PTR

For Course PTR:
Publisher and GM of Course Technology PTR:
Stacy L. Hiquet
Senior Marketing Manager: Sarah O'Donnell
Marketing Manager: Heather Hurley
Marketing Coordinator: Jordan Casey
Associate Acquisitions Editor: Megan Belanger
Manager of Editorial Services: Heather Talbot
Editorial Services Coordinator: Elizabeth Furbish

ISBN: 1-59200-649-3

5 4 3 2 1

Library of Congress Catalog Card Number
2005927333

Educational facilities, companies, and organizations
interested in multiple copies of this book should
contact the publisher for quantity discount information.
Training manuals, CD-ROMs, and portions of this book
are also available individually or can be tailored for
specific needs.

COURSE PTR,
A Division of Thomson Course Technology
(www.courseptr.com)
25 Thomson Place
Boston, MA 02210

This book was conceived, designed, and produced by:
ILEX
Cambridge
England

Publisher: Alastair Campbell
Managing Director: Stephen Paul
Creative Director: Peter Bridgewater
Managing Editor: Tom Mugridge
Project Editor: Stuart Andrews
Art Director: Julie Weir
Design: Chris & Jane Lanaway

Printed and bound in China

For more information on this title please visit:
www.web-linked.com/nphous

Introduction

I have always been fascinated by night and low-light photography, shooting at times when many other photographers would have packed up their gear and gone home, thinking there is nothing left to shoot. If that sounds like you, then you are missing out on some of the most exciting and rewarding photography possible; a form of photography that enables you to capture even the most familiar subjects with a rare beauty that transcends the standard photographic clichés. If you have tried it and failed on your first attempt, don't be put off! This book will teach you how to shoot successfully, every time you go out and in many different low light situations.

Low-light photography is a demanding, but ultimately rewarding pastime. The latest digital cameras allow you to get more accurate results more often—you can preview the results straight after shooting, and take as many shots as you like without any concerns over wasted film. However, don't be fooled into thinking that a digital camera will miraculously produce great results every time you click the shutter. That takes time, technique, and practice.

That's where this book comes in. Whatever camera you use or subject matter you favor, *Digital Night and Low-Light Photography* will help you learn methods that can make your images better and more exciting. Find inspiration in the examples and techniques we describe, then get out and start shooting photographs to make you proud.

Digital Cameras and
Camera Equipment

Choosing a camera for low-light photography

With so many products in the digital camera market, the hardest decision most photographers make is which to choose. This will depend on several factors—budget in particular. This may be the choice between a top spec compact or just a DSLR and one lens. Do you already own lenses that can be used on a new DSLR? If so, you probably don't want to start an expensive lens collection from scratch again. How much would it cost to copy your collection to a new system?

Also, think about the sort of photography you want to do. Landscapes benefit from wide angle lenses between 17mm and 35mm, while for portraiture 50mm to 100mm is ideal. Sports or wildlife require long fast telephotos of 300mm and beyond. Are you prepared to cart around a bagful of lenses? If not, buy a quality compact.

Basic compacts

There are some digital camera bargains out there, but as a rule, the less you pay, the less you get. A smaller focal range and a low megapixel count means you will struggle to get much use from a cheaper compact and will soon find that its limitations are holding back your creativity. Buy one for snapshots of the family or to put in your pocket for weddings and parties.

The Olympus C-7000 zoom (below) sports a seven megapixel sensor and 5x optical zoom. The Fujifilm FinePix F810 (lowest) offers 6.3 million pixels and a 4x optical zoom.

The Canon PowerShot G6, while undoubtedly compact, offers a certain extra flexibility, in the form of lens attachments and even a remote control.

Quality compacts

Often called "prosumer" cameras, these give you a much higher pixel count, often up to 8 megapixels, which can be as good as the more expensive digital SLRs. For portraiture, you could get away with a quality compact with a focal range from 28/35mm to 280mm, and this will also do for occasional landscapes and wildlife shots. Wide/telephoto adaptors are often available, which can be screwed to the end of the fixed zoom lens. These are good, but don't expect them to produce the quality of a prime lens (one with a fixed focal length) designed for the job.

Digital SLRs

For best results, use the same sort of camera that a professional photographer would use. Digital SLRs enable you to change lenses, so you can build up a collection over time. This will then enable you to tackle any subject—you just attach the right lens for the right job.

You will generally have more exposure modes and high-quality flash modes not available on cheaper models. Some cameras enable you to fire several flashes remotely at the same time, yet maintain a correct exposure because the flash system is linked directly to the camera's electronics.

Shooting rates (frames per second) are faster, enabling you to take more shots per second, and most digital SLRs have excellent memory buffers, enabling you to shoot many frames to a high-speed buffer, which are then transferred to the slower memory card.

Finally, digital SLRs are usually more sensitive. Most go up to ISO 1600, while most quality compacts can manage only up to 400 or 800 ISO. In addition, noise is more effectively controlled at these levels, and shutter speed ranges are often better. On a digital SLR, the top speed may reach $1/8000$ sec to $1/12,000$, while the longer slow shutter speeds will go up as far as 30 seconds.

SLR cameras like the Konika Minolta Maxxum 7D (top) and Nikon D2Hs give the flexibility of interchangable lenses, as well as faster processing.

Features

Some camera features are common; others will appear only once you go up the range to top-end prosumer models and digital SLRs. Not all are as useful or important as the manufacturers may tell you. Equally, some specifications are more vital to consider. If you're buying a camera for low-light photography—or any kind of serious shooting—then consider the following carefully: CCD sensors and the megapixel resolution.

The array of light-sensitive cells at the heart of a digital camera—usually called the CCD—is rated in terms of megapixels. Each megapixel equates to one million pixels, and describes the number of pixels an image taken with the camera will contain. Now, megapixel resolution isn't everything—the camera's optical systems and color capture technology are equally important to the final result—but, as a rule, the more pixels contained in an image, the higher the quality will be and the larger you will be able to make prints. Ask yourself, what is the largest print size I will print to regularly? For 6x4" you could get away with the cheapest 2 megapixel cameras, but for 7x5" that rises to 3 megapixels, or 6 megapixels for a 10x8". In reality, you can enlarge an image beyond these sizes without disastrous results, but having pixels to play with gives you more options later to crop and manipulate the image.

RAW vs. JPEG file capture modes

A RAW image can be described as a digital negative; it contains all the highlight and shadow detail, plus all the original camera data, and information on the settings used. Most good-quality cameras offer two or three file formats in which you can store your digital images: RAW being best, a fine-quality TIFF coming next, and a standard JPEG format fine for basic, everyday shooting. JPEG files are compressed, meaning you can fit more shots on a memory card, but at the cost of clipped colors or highlight and shadow detail. If quality is paramount, stick to TIFF or RAW.

Shutter speed and memory buffers

The better the camera, the higher the range of shutter speeds available. The fast end—up to $1/8000$ sec—is perfect for high-speed action photography, but in low-light photography we need more room at the low-speed end: preferably a shutter speed of up to 30 seconds and also a bulb or "B" setting.

Viewfinder

Digital SLR cameras use the same pentaprism mirror system found in their conventional film equivalents, giving you the best chance of getting what you see

Digital SLR cameras like the Canon Digital Rebel XT can save images in the RAW format, which provides more flexibilty (but can be more time-consuming) when you get to the computer.

on the viewfinder when you take the shot. Fixed lens cameras may only allow viewing via an LCD screen or a lower-quality optical viewfinder. Some have adopted an electronic viewfinder. These are good, but detail is limited, so you won't see all you would with a digital SLR. They also consume battery power, which is critical for low-light work.

Aperture

All lenses use an iris or diaphragm to alter the amount of light falling onto the sensor. Fixed lens cameras often have a disappointing maximum aperture, but a digital SLR gives you the option of buying a fast specialty lens designed for low-light shooting. Remember, faster lenses also make the viewfinder brighter, as they let more light in.

ISO range

Look for a wide ISO range: 100 to 1600 is good, but some cameras offer an extended range of 50 to 3200 ISO. The best use software to produce almost noiseless images even at such high ISO settings. The EV range is also worth considering, with cameras offering a range from 0 to 20 being the best. The higher the EV range, the more accurate exposure will be at lower light levels.

Start-up times

Start-up time and shutter lag can hinder the performance of cheaper cameras. Some take several seconds to start up, which may mean the difference between getting a shot and losing it. Shutter lag (the time taken to expose a picture after pressing the shutter) can also be quite long, again losing you a chance for a better second shot. On a quality camera, these problems should be practically non-existent.

AF system

Although less important for landscapes, a fast and responsive auto focus system is always useful, particularly for sports and wildlife work. The best systems work even in low-light situations, when others fail to respond properly and "hunt" too much. Some systems use 45 points of reference to give superb response across the entire frame. You also need the option of a manual focus, for those tricky situations that fool even the best AF systems.

Exposure mode dial

High-end cameras don't usually have the exposure programs used by consumer-level cameras. Instead, you have four basic modes: Program mode, Shutter Priority, Aperture Priority, and Manual.

Flash systems and accessories

Professional cameras enable several flash units to be used at once. A dedicated flashgun will also help maintain correct exposure. Pro spec models don't usually have a built-in flash, but a hotshoe connection to attach a separate flashgun or any number of specialty flash accessories. Cheaper cameras won't support these, and may be limited to a small built-in flash.

Custom functions and LCD screen

Check to see how many functions can be changed using the menus accessed via the LCD screen. The more functions you have, the more flexibility you have to solve any problems that crop up. Better cameras have bigger, more accurate LCD monitors. These aren't just for show: they can help in accurately checking colors and exposure.

White balance

This control corrects any color casts detected in the scene by the camera. Professional cameras allow for even more fine-tuning—some even have color correction settings in Kelvin mired shifts (see page 36), which will be of special interest to interior photographers.

Storage and memory cards

There are several types available, CompactFlash being the most longstanding, with the largest memory capacities (up to 4GB). With a Type II CompactFlash slot, you can also use a Microdrive: a tiny hard-disk that stores huge amounts of data. Other formats include Memory Stick, SD Memory Card, and XD Memory Card. In real use, there's little difference, only variations in price and maximum capacity.

Lenses

For serious photography, and the flexibility to shoot across a vast range of styles and subjects, it makes sense to have a selection of lenses at your disposal. Of course, this will depend on what type of camera you have; if you only have a budget for a fixed lens compact, you will be limited to one lens plus any wide-angle or telephoto converters, making it vital to choose one with the best optical zoom range. For maximum flexibility, get a digital SLR. That way, you can always buy more lenses as you go, or even hire them in for special jobs.

Angle of view with smaller sensor designs

In this book, for ease of description, all lens focal lengths are based on the standard full-frame 35mm camera. Apart from a few full-frame sensor cameras, manufactured by Canon and Kodak, most cameras feature a smaller CCD or CMOS sensor. As a result, they effectively multiply the focal range of a given lens by a value of between 1.5 and 2. This would effectively turn a 28mm wide-angle lens into a 42mm one, which is almost a standard lens. By extension, a telephoto lens of 300mm will become a whopping 450mm. Clearly, this affects landscape and architectural photographers more than sports or wildlife photographers. Always check the focal factor with a camera design, as it may affect the type of work you want to do.

Wide-angles

The first group of lenses to consider are the wide-angles. The focal factor mentioned above means wide-angle lenses need to be extremely wide to generate a wide enough angle of view. As a result, new digital lens designs are available, creating extreme wide-angle lenses of about 10–12mm, equating to 15–17mm on a standard 35mm camera. Depth of field is very good, as wide-angle lenses are sharp from front to back at around f8 unless shooting close-up.

Standard lenses to short telephoto

Standard lenses are found around the 40–60mm mark, and this equates with the angle of view of the human eye. A typical 50mm lens design is small, compact, lightweight, and fast. The average is f1.8, but f1.2 or f1.4 lenses can be purchased at greater expense. The prime 50mm lens has been superseded by a zoom as the standard lens purchased with a camera. This is great for general photography, but a super fast f1.8 lens can be very useful for nighttime photography.

Macro lenses

Most macro lens designs fall into the 50–100mm focal range, and can focus up to life size and beyond with an extension tube. Their design is optimized for pin-sharp macro work; even a zoom with a macro facility won't produce such good results.

Telephoto lenses

True telephoto lenses start at about 150mm, where you begin to see a significant magnification of your subject. Perspective is compressed, which is more apparent where your shot has a distinctive background. Modern designs offer the sports and wildlife photographer some very fast apertures—up to f2.8—assuming a generous budget. New designs use extra-low-dispersion glass to correct chromatic aberrations. These "apochromatic lenses" make all light wavelengths focus at one point, critical for strong telephotos. The telephoto is the one lens that benefits from the focal factor issue—a 300mm lens becomes a 450mm lens with a focal factor of 1.5.

Camera shake is telephoto's big problem, since it's also magnified. The slightest nudge can blow a shot, so use a tripod, weighed down if possible, and a self timer or cable release. Some lenses have VR (vibration reduction) or IS (image stabilization), using a special gyroscopic motor to counter any camera shake.

Zoom lenses

Modern zoom designs have improved dramatically with computer-aided design and special aspherical plastic/glass hybrid lenses. Such methods allow for fast and ultra-wide lenses, ideal for digital cameras. It's possible to cover all the major focal lengths you'll need with just two or three zooms. Pro zooms offer prime lens quality and speed. Slower, more affordable lenses are still a viable option for quality work, though a tripod will be needed more often.

Wide-angle adaptors can be used, but for the best quality buy a purpose-built lens.

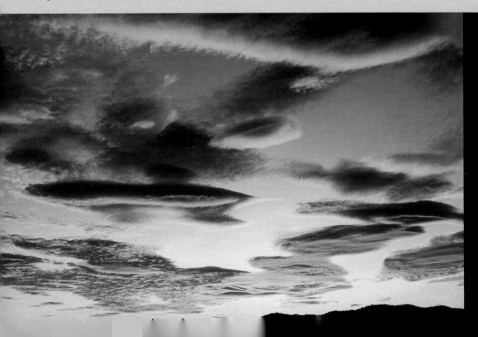

TIP

Always try to buy the best lens you can afford. The more you pay, the better the quality. Independent lens manufacturers like Sigma and Tamron offer high-quality lenses at more affordable prices and are worth checking out.

A 35mm wide-angle lens captures the full scale and beauty of this dramatic sunset.

Flash and other lighting equipment

Flash photography is, at first, daunting and difficult to understand. It's seemingly impossible to get a correct exposure. This leads some to prefer tungsten lighting, though both have their benefits.

Both these flash-guns clip into the hotshoe found on all SLR cameras, and can be turned to bounce from the ceiling for a softer lighting effect.

Types of flashgun

Although some cameras have a built-in flash, these are not very effective if you want to do reportage-style work on location or serious studio-based portraiture or still life. For location work, it is often best to travel light, so you should choose from a small flash that attaches to your camera's hotshoe or use a hammerhead style flash that attaches to the side of your camera via a bracket. This design is useful, as it moves the flash to the side, which improves the modeling of the subject and reduces red-eye problems. Both designs usually enable the head to be rotated up for bounced flash. A Metz flash, for example, can be rotated up and sideways, enabling you to bounce off a ceiling or wall. Nikon and Canon cameras allow for the use of several dedicated flashguns at once to create a studio style set up on location.

Dedicated flashguns

If you buy a manufacturer's flashgun, it will have maximum TTL dedication, meaning it meshes closely with the functions of your camera, enabling you to get optimal use out of modes and settings. Check if third-party flash units have maximum dedication or whether some functions won't work. Manual-only flashguns need more experience to use, but prove ideal for lighting large areas, like backgrounds or interiors, which don't need precise exposure settings.

Monoblocs and lamps

These are primarily studio-based flash systems (though monoblocs are also used on location). Both systems generally use mains power to allow for much more powerful designs than flashguns, meaning you can diffuse the light source for softer effects while maintaining high light levels and fast shutter speeds. Also, the recycling times (while the flash recharges) are faster, and you can position the light very accurately. A powerful flashgun has a guide rating of 40 and an average 500W monobloc light has a guide rating of 80, so you can see the difference in power output.

Lamp systems have to be plugged into a main power supply unit. These can be quite large and you need one for each group of lights. For example, lights placed at different ends of a room would need two. Monoblocs have their own built-in power supply, making them easy to transport and set up, and so in turn more useful on location. Lamps can produce much more power than monoblocs, but you need this only in a large studio-based system. The downside to these systems is that they are manual only, so you'll need to work out your exposures first, using a flash meter.

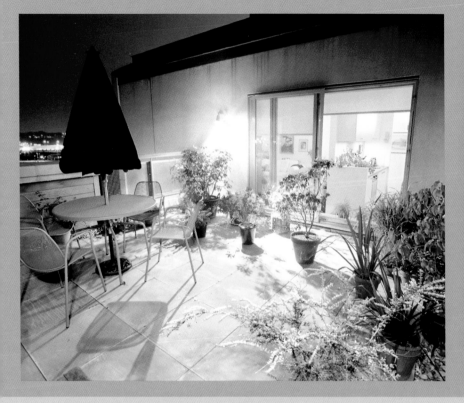

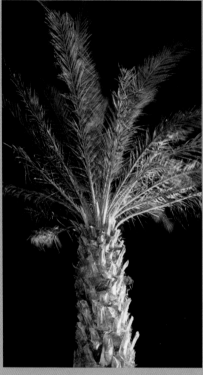

Flash meters

A good flash meter can be used with or without a cord, so it can be easily placed some distance from the flash units. It should come with a white invercone for incident light readings. This method reads the actual light source using the white cone, which is diffused and pointed toward the light to give a very accurate reading of the light source. Good-quality meters incorporate a flash and ambient meter so you can take daylight readings (incident or reflected) as well.

Flash vs. tungsten

One alternative to large monobloc systems is to use tungsten (or incandescent) lighting. The main advantage is a much lower cost and that you get what you see (although most monobloc systems do have tungsten modeling lights to "preview" the effect). You will need to filter the light using blue gels as, unlike flash, which is daylight balanced, tungsten lighting creates a strong yellow cast. Alternatively, use the Incandescent White balance setting on your camera.

 The main drawback is that they emit a lot of heat: a problem in a small room (though a bonus in winter!). A cooler alternative is to use a fluorescent tube system, which emits similar amounts of light but without the heat. Tubes are daylight balanced, but the systems are usually more expensive than tungsten.

Above left A typical night scene. There was some ambient lighting to work with, but I used a flashgun fired at full power to brighten up the foreground.

Above A single palm tree was lit by a tungsten floodlight and I added a single flash to add more detail.

Useful **accessories**

There are hundreds of accessories available for the keen photographer, but only a few are truly essential for anyone with a serious interest in the art. Tripods and supports are vital to low-light photography, while the cable-release has obvious benefits in an area where long exposures are the norm.

A full-sized tripod is not always practical or necessary. There are many situations where a mini-tripod and a wall will team up successfully.

Tripods and other supports

The one item that can instantly transform your photography is a tripod. It slows you down and makes you think about your subject rather than taking a quick grab shot. It enables you to compose your shot precisely and wait for the optimum moment before shooting. With your tripod set up, you can wait for the right light to arrive, knowing the composition is exactly how you want it. With a tripod, you can take a series of shots as the light changes, shooting at very slow shutter speeds without getting camera shake.

This last function is crucial. Hand-holding a camera and shooting at slow shutter speeds, or using small apertures is one of the most common reasons why shots fail. Night photography, where exposures can run into many seconds, cannot be taken without a steady camera. In addition, smaller apertures can be used when shooting with a tripod, resulting in a sharper shot from foreground to background.

Telephoto and macro lenses are very prone to camera shake, due to their high magnification of the subject. The only way to ensure successful shots with such lenses is to mount the camera on a tripod.

Mini tripods and bean bags

Very small tripods are available and these can be set up on a table (some designs can be clamped to a window or other support). These are useful when a large tripod is not available or too intrusive. Some places ban tripods, so a small tripod is a good way of adding stability without attracting too much attention. Bean bags are a useful lightweight support. As they shape around the camera, they help maintain a steady shot from walls or flat surfaces.

Cable releases

Another must-have for serious night photography, where depressing the shutter button can add camera-shake just at the moment of exposure. If you have no other option, depress the button very slowly and carefully, then gently release, but this becomes difficult when using the "B" or Bulb setting (for exposures greater than the longest shutter speed available, which could be anywhere between 1 and 30 seconds). A cable release enables you to press the button once without jarring the camera, and a locking design means you can let go during the exposure.

Sadly, some cameras don't have a screw thread in the button, which forces you to invest in a more expensive, proprietary electronic release.

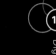
TIP

As a final resort, use your camera bag as a support as you would a bean bag. I have successfully taken night shots in this manner by using the self-timer to minimize camera shake.

Left A light tent is used to provide even lighting conditions for the subject, an electronic organizer, with a reflector to angle the flash.

Below A Velbon CX tripod. Despite weighing just 3lb (1.5Kg) it provides a sturdy base for a camera twice that weight, and has a quick-release head.

Level

This small, often overlooked item can save a lot of work later on. Some tripods already have a level built in, but a small level can be attached to the hotshoe so you never have a wonky horizon again. The level can be tucked away in a gadget pocket in your camera bag.

Torch

A torch should always be carried in your bag when out taking night shots. It enables you to check your control dials to adjust things like aperture, shutter speeds, and ISO settings. It also lets you rummage around in your otherwise pitch-black camera bag for items like filters or spare batteries. In more remote areas, it also helps you manage rocky terrain without losing your footing. I keep a spare in the car for general emergencies as well.

Lens hoods

This is a great way to improve picture quality, and one that many people aren't aware of. Flare can be ruinous to contrast. Even a tiny amount can have a detrimental effect, and it is not always apparent, either—your pictures can just look flat and lifeless.

Some telephoto lenses have built-in retractable sliding lens hoods, while some wide-angle lenses have special attachments that come with the lens. If you need to buy a lens hood, make sure you get the right type and size. Wide-angle lenses need shallow and wide hoods to stop vignetting, while telephotos need long, deep hoods. Get advice from the lens manufacturer if in doubt. Alternatively, small black flags can be attached to the camera via a bendable metal cable, and these can be moved to precisely the right position. Lens hoods with filter systems get complicated and expensive, but you will certainly need something, even if it is only a small black card or your hand held between the sun and lens.

• Keep a pen and pad for notes of weather conditions or as a record of locations visited or to be visited. You can also create a checklist of all important small and big items that you will need. Tick each one off before leaving.

• Take at least one small jeweler's screwdriver with you to tighten up any loose screws (they can occur if your equipment is used regularly). Check your gear for problems on a regular basis and always wipe it down with a damp (not wet!) cloth after usage, especially if you have been near the sea or sand.

• You can keep many of the items mentioned above in a small bag that fits around your waist. Keep it inside your camera bag, then take it out and wear it when you get to your location.

• A small plastic bin liner comes in handy on many occasions. Use it to wrap around your entire camera bag if it gets very wet, or put it on wet or sandy ground to keep your bag clean and dry.

• During winter months, keep warm clothing in the boot of the car in case you suddenly have a photo opportunity when least expected.

Useful **accessories**

Reflectors and black card

Reflectors can come in very handy to push a bit of light back into dark areas of a photo. You can buy ready-made reflectors in many sizes, but you can easily make one using a sheet of thin card, which can be folded up and left in your camera bag. Gold adds a warm glow, white a subtle neutral effect, while silver gives the strongest effect of all. The bigger the subject, the larger the reflector required. Another useful item is a small sheet of black card that can be used to stop flare, or put in front of the lens when you want to "freeze" a long exposure part way through—for example during a firework display.

Spare batteries and memory cards

There is nothing worse than running out of power halfway through the day, making a spare set of batteries essential for each piece of equipment that uses them. Cameras should have at least two extra batteries, especially if using the built-in flash. An in-car battery charger is extremely useful if going on an extended trip away from a reliable electricity source.

Just like film, you need enough spare memory cards to get through the day. The cost has dropped significantly, so there is no excuse not to carry an extra card (or preferably more).

If you have deep pockets, consider a portable storage device. These hard-disk based devices range between 20 and 80GB, run on batteries, and accept a variety of memory cards directly, so they can be downloaded virtually anywhere. Alternatively, keep a notebook computer and a CD burner in a secure place nearby.

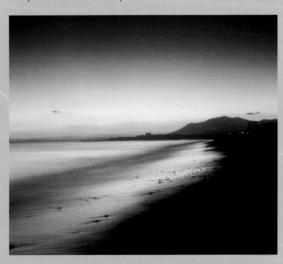

Shot with a 35mm wide-angle, this exposure was 8 seconds at f11. The long exposure has blurred the sea to give a lovely misty effect, but this would have been unthinkable without the aid of a tripod.

Digital vs. film

Many photographers are still shooting film and digital side by side, so it is worthwhile assessing the good and bad points of each system.

Film

Film has been around for many years and the latest emulsions offer top quality with high sharpness and fine grain. A professionally scanned 35mm transparency will yield a file size of approximately 60MB, enabling very large prints to be made. The downside is you need to have a quality scanner or pay a bureau to make the scans. This isn't cheap, but you would need a digital camera of around 10 to 12 megapixels to get similar quality. Film is still a fantastic storage medium—one 35mm film can hold the equivalent of a 2GB memory card of RAW files—and a negative can be archived for many decades without any problems if stored properly. CD or DVD media corrupt in only a few years, so several back-ups would be needed.

However, costs need to be taken into account, and these can be very high if you shoot a lot of film. For a photographer spending many thousands on film and development, it is tempting to buy a top of the range 35mm digital camera, save money, and still have film quality. The latest 16 megapixel offering from Canon even competes with medium-format cameras.

Digital

Digital is relatively new and the camera specs change every time you blink, meaning your camera will be out of date within six months. The definitive quality has yet to be achieved, but most cameras now offer a quality that ranges between very acceptable and excellent. Digital also means you don't have to spend time scanning shots in, and you don't need a scanner unless scanning old slides.

Admittedly, specialist films like black-and-white, or color infrared, or high-speed films are not available to digital users and their effects are often difficult to replicate exactly. However, you won't have any film or processing costs and you can choose which images to print. This means big savings on time and money, even if the cameras are more expensive than their film equivalents.

The conclusion

If you already have a film camera and many years' worth of slides, you may want to invest in a film scanner rather than a digital camera and continue shooting on film. If you have the budget, get a digital camera, as it will possibly transform your image-taking and enable you to freely experiment without the pain of wasting film. The ability to see what you have just photographed will eventually give you more confidence that you are getting the shot right.

2

Camera
Techniques

Exposure and metering

The right exposure is critical to successful photography. It's all about finding the perfect balance of shutter speed and aperture to correctly expose your subject with a full range of tones. Sometimes you may want to break the rules to produce a very dark (low key) or very bright (high key) image, but you must understand the way a picture is exposed in order to do this with any control.

The aperture

The aperture (also known as the iris or diaphragm) has been designed to open and close in incremental steps called f-stops. Most lenses have full, half, and $^1/_3$ f-stop increments for finer control. Expensive lenses usually have a larger aperture and therefore make faster shutter speeds possible. For example, a lens with a maximum aperture of f2 will allow for two stops more light than a lens of f4. This is very useful in low-light conditions.

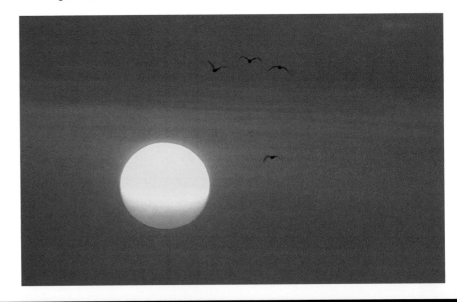

This shot, cropped from a larger picture to emphasize the birds in motion, uses a slow $^1/_{60}$ sec shutter speed to add a sense of movement. Experiment with exposure settings to find the right one for your shot.

MAXIMUM APERTURE										MINIMUM APERTURE
f 1.2	f 1.4	f 1.8	f 2	f 2.8	f 4	f 5.6	f 8	f 11	f 16	f 22
$^1/_{2000}$	$^1/_{1000}$	$^1/_{500}$	$^1/_{250}$	$^1/_{125}$	$^1/_{60}$	$^1/_{30}$	$^1/_{15}$	$^1/_8$	$^1/_4$	$^1/_2$

Once the correct combination of aperture and shutter speed has been chosen for the exposure (e.g. $^1/_{60}$ at f4), the following rule applies:

One f-stop increase (from f4 to f2.8) admits double the light of the previous aperture, so the shutter speed has to be halved to compensate (i.e. $^1/_{125}$ at f2.8)

One f-stop decrease (from f4 to f5.6) admits half the light of the previous aperture, so the shutter speed has to be doubled to compensate (i.e. $^1/_{30}$ at f5.6).

Auto programs

Of course, while setting aperture and shutter speed manually is the key to total control, it's a laborious process, and one that can prevent you from getting the perfect shot in time. Luckily, in many situations you can rely on your camera's built-in exposure programs.

AUTO PROGRAM (P)

The camera will choose the correct aperture and shutter speed for the exposure, and will use stored exposure situations to come up with the best combination. You can usually change the aperture or shutter speed dial to suit your own requirements.

SHUTTER PRIORITY (S/TV)

You set your desired shutter speed and the camera automatically selects the aperture for correct exposure. Shutter priority can be used to freeze fast-moving action or slow down the speed for blurred motion effects.

APERTURE PRIORITY (A/AV)

You set your desired aperture and the camera controls the best shutter speed for correct exposure. Aperture priority can be used to control depth of field. A large aperture will give shallow depth of field while a small aperture will enable depth of field to be maximized for any given point of focus.

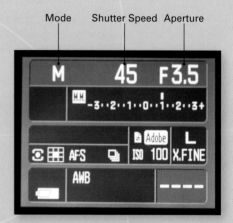

Mode Shutter Speed Aperture

The camera's LCD display should provide you with detailed information on your current mode, shutter speed, aperture, ISO, and focus settings.

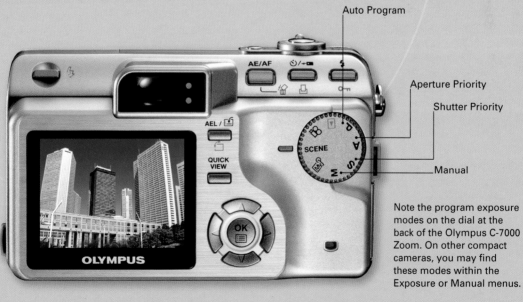

Auto Program

Aperture Priority

Shutter Priority

Manual

Note the program exposure modes on the dial at the back of the Olympus C-7000 Zoom. On other compact cameras, you may find these modes within the Exposure or Manual menus.

Exposure and metering

Exposure meters

An exposure meter works by trying to see all images as a standard 18% gray. It arrives at this by mixing up all the light and dark areas to create a gray mix, then selects an exposure to bring that gray to 18%. This is fine in principle but if the light and dark tones are unequally mixed—as with a snow scene that has few dark tones, or a coal mine that has few light tones—then the meter will be fooled into the wrong exposure. White snow goes a mushy underexposed gray color and the coal mine also goes grey but overexposed. To make the gray whites pure, you need to deliberately dial in $1^{1}/_{2}$ to 2 stops of overexposure. To make your blacks truly black, do the opposite—1 to 2 stops of underexposure (see Bracketing and exposure compensation on page 28 for more details).

On a good digital camera, you should have access to the following metering modes. By choosing the correct mode for your subject or choice of composition, you should be able to get the best exposure for each individual scene and shot.

Center-weighted metering

This is an older metering system that takes a reading from the central part of the viewfinder. This is most useful when taking portraits, as the subject is often centrally placed.

Multizone/matrix metering

The main metering system found on modern cameras. It offers excellent exposure control with over 1,000 pixels being used for the segment metering. Some systems also take color and distance into account. This assures consistent exposures for most lighting situations.

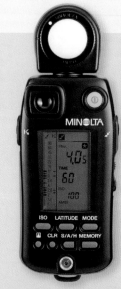

Above Incident metering should give you an unbiased reading of the light falling toward your subject, though you should choose the area you read from carefully.

Below With few dark tones to work with, the meter is fooled into underexposing. To obtain purer, brighter whites, deliberately dial in $1^{1}/_{2}$ to 2 stops of overexposure.

correct exposure

underexposure

Spot metering

Good cameras also enable you to take a spot reading, in which the camera uses a very narrow area in the center of the viewfinder to take a reading. This is a very accurate way of metering, and especially useful with a zoom. You can get pinpoint measurements of midtones or make an accurate shadow/highlight reading.

Incident meter reading

Hand-held meters can be used to take reflected light readings. You simply attach a white sphere (known as an invercone), which is pointed towards the light source and, in theory, will take an unbiased reading of the light falling on your subject. If your subject is in the shade but you are standing in the sun, you must remember to take a reading from beside your subject. Get as close as possible or be aware of your position relative to your subject. It is possible to buy an invercone that covers your camera lens, and this is used in the same way.

If you need to take a reading of reflected light, choose the area you meter from carefully. Bright colors or dark areas could wrongfoot your meter either way. Dark green grass, normal blue skies, and gray sidewalks are good examples of midtone colors—they're not too dark or too bright—so take several midtone readings from these and use the average. Alternatively, use a spot meter reading to take a shadow and highlight reading and split the difference (e.g. $1/125$ at f8 highlight and $1/8$ at f8 shadow—the difference would be $1/30$ at f8).

One final option is to use a gray card (available from all good photography stores). Place the card next to the subject, or in the same type of light, and take a reading with your camera. This will produce a similar result to the incident method.

Above Use a gray card placed next to the subject to help the meter obtain a solid reading.

Below left Night-time shots demand a tripod, a cable or electronic shutter release, and a lot of patience. Shot with a 50mm lens, with a 15 second exposure at f11.

Below center This Moroccan style building was actually shot at the amazing Walt Disney studio in Florida, where all the world's themes can be seen under one roof. Shot with a 50mm lens at f8 for 5 seconds.

Below Shooting into the sun turns your main subject into a silhouette if you don't increase the exposure by up to 2 stops. In this case the deliberate underexposure has enabled the pier to go black, creating a powerful form enhanced by the soft muted sunset behind. A 210mm lens was used.

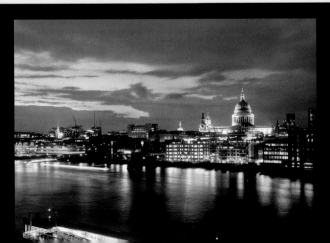

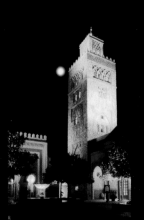

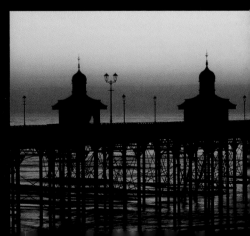

Bracketing and exposure compensation

Bracketing your shots is the failsafe way to ensure you get at least one exposure spot on. Exposure compensation enables you to fine-tune the exposure manually.

Bracketing

One of the best ways to secure the best exposure is to cheat! Whenever you take a shot, always bracket your shots to give one correct exposure, one under and one over. You can fine-tune this to give several exposures in 1/2 or 1/3 stop increments for even finer control. If memory card space is getting tight, just review your shots and delete the exposures that are obviously wrong. The bracket button should be on the top or back of the camera for easy access. This is great when shooting fast-moving action where you don't have time to alter the settings manually.

Exposure compensation

Good cameras will have an external button offering fast and easy access to the exposure compensation settings. It is usually situated conveniently next to the shutter-release button so you can reach it quickly and intuitively. Some cameras allow up to five stops exposure compensation above and below the correct exposure in 1/3 stop increments. For most situations, this would be overkill, but it's nice to know it's there. Most situations rarely need more than three stops compensation. Bracketing is usually a better system for exposure control, but if you need permanent exposure compensation built in for shooting in snow or low light, it can be useful.

AE/AF lock

Another useful button enables you to lock exposure, or focus, or both simultaneously. I prefer to use it as an exposure lock button, and this can often be changed using the custom settings menu. The benefit is that you can quickly take a correct reading from a known source, and then recompose. For example, when shooting into the light, point the camera and take a reading to the side of the bright light source first, in order to get the correct reading. Then use the AE lock to hold the setting.

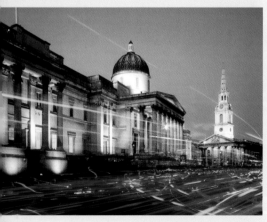

Left Top The Bulb setting in action. For this exciting image of speed and action, I opened my sunroof, poked a tripod out, and composed the shot before setting off. A cable release was attached so I could safely keep firing off several exposures as I went down the road.

Left The Bulb setting is equally useful for capturing light trails (see page 114). I stood by the roadside and used a very long shutter speed of 90 seconds with a cable release on the Bulb setting. It was shot in rush hour, so there was no shortage of subject matter!

This hibiscus was shot in Jamaica on a dull, wet overcast day, with a polarizer used to reduce reflections, and the exposure extended to $\frac{1}{2}$ second. I bracketed the white balance to ensure a decent shot.

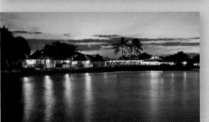

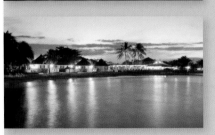

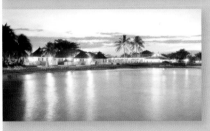

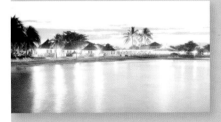

Bracketing/white balance compensation

You can bracket the White Balance in the same way as the exposure. It is usually accessed via a White Balance custom menu and increases the values in increments of 10 mired (Micro Reciprocal Degrees), except for fluorescent, which uses greater shifts to compensate for the effects of different types of tube. On many cameras, it can be easier to access changes via the White Balance button. With the button depressed, use the aperture dial to input mired shifts up or down.

Bracketing/flash compensation

Again, the principle is the same. If you have a flash exposure compensation button, you can increase or decrease the power of the flash. If the TTL flash is not quite correct, you can use this button to fine-tune it. Choose + to increase flash output and - to reduce flash output. Using -1 or -2 allows for a more natural fill-in flash when shooting portraits close up.

THE BULB "B" SETTING

When your longest shutter speed still isn't enough, you know you must be shooting in an extremely low light. Quite often the longest shutter speed available may be only 10 seconds. Even pro spec cameras rarely go beyond 30. The solution is to use the Bulb setting, or "B," as it is often written on old-fashioned shutter speed dials.

The Bulb setting keeps the shutter open for as long as you press down the shutter release button (though some cameras cut off the exposure after a minute). Obviously this means you need a tripod and a cable release to get an effective result. Some subjects benefit massively. With a firework display, you can keep the shutter open and use a black card over the lens in between lulls in the display (see page 130), enabling you to build up several big bursts. Star shots have to be shot using this method, as the exposures run into hours, not minutes (see page 110). You also need to use the Bulb setting for painting with flash techniques (see page 74). The Bulb setting uses lots of power, so make sure you take spare batteries with you.

As you can see from this series of bracketed exposures from -1 stop to +4 stops, there is a wide difference in the tonal range. For most night shots you don't really need to waste memory card space by underexposing unless you are worried about some extremely bright areas you may want to preserve. I usually expose 0, +1, +2, and +3. This is so I can use the brighter sky from a more overexposed shot, say +2, and montage it with the +1 or 0 image.

Using **lens filters**

While Photoshop and its rival image-editing applications have made some filters redundant, others are too important, or their effects cannot easily be recreated in software. Filters can still play a leading role in your image-making process.

Lens filters are available in two basic designs; the first are the old-fashioned screw-in filters, and the second are the more modern modular designs that are placed in a special universal holder attached to the lens. A filter kit is required, which screws into the lens using a lens adaptor ring, and the filter is placed in a holder so it can be rotated. The beauty is that you only need to buy one filter size and a separate lens adaptor for each different lens diameter.

If you want to use the screw-in type, they will fit only one lens thread, so you need to buy a filter for your largest lens diameter and use step-down rings to fit smaller lenses. This works well, but it also makes these filters slower to attach and use. The square filter designs—which come in kits from Lee, Cromateck, Cokin, and several others—remove this problem. In fact, you can leave a lens adaptor on each lens and then attach the relevant filter when needed, without any need to fiddle around with step-down rings. This makes them a more practical option for real-world use.

The polarizer

This is one filter effect that cannot be fully recreated using color saturation in Photoshop, as the lightwaves need to be physically altered before entering the camera lens.

This is an essential filter and can do several jobs depending on your requirements. Its primary task is to polarize the light as it enters the camera. Light travels at different angles, and it's this that causes glare on shiny, non-metallic surfaces. The polarizer removes these wavelengths, improving clarity and color saturation, especially in skies, which often turn a much darker blue. This can have a startling effect on your image and give it a tremendous boost. The effect is at its maximum when your lens is at a right angle to the sun. It works just as well after the sun has gone down, and can boost an insipid dusk sky.

That's not all. Wet leaves, water, and glass all become more transparent when shot through a polarizer, and distracting reflections are much reduced. The effect is at its maximum when the lens is at a 45º angle to the reflective surface, and it also means this technique can be used to shoot brightly lit window displays at night.

Polarization does not occur evenly across the sky, and you must take care—especially with wide-angle lenses—that you don't get uneven banding halfway across the sky. The filter has little or no effect with the sun directly behind or in front of you. A gray grad filter (see page 32) can be used to darken any lighter areas that haven't fully polarized, or you can just fix the problem later on in Photoshop.

The main drawback to using polarizers is the two-stop loss of light it causes. This means you must be careful about handholding, as shutter speeds can drop to levels where camera shake is possible. This weakness can be used to your advantage, as the filter can double up as a neutral density filter and allow far slower shutter speeds in bright light. Use it with the dark area of a gray grad filter to get even slower shutter speeds.

Polarizers come in two types: circular and linear. Both do the same job, but circular polarizers need to be used for auto-focus lens systems and cameras with semi-silvered mirrors. Check your directions manual for details before buying, or, if in doubt, buy a circular polarizer.

Vignetting problems

Care must be taken when using filters, or you will get a darkening of the corners, known as vignetting. There are some filters which do this deliberately, but for most shots you want a uniform exposure across the entire image. Wide-angle lenses are especially prone to vignetting, so use the largest filter kit size, 75x75 or 100x100 (for extra-wide lenses) to overcome this problem. Stacking several screw-type filters together can also cause vignetting, even with moderate 28mm wide-angle lenses, as the filters jut out so much they interfere with the light entering the lens. On extreme wide-angle lenses, even one standard screw filter can cause problems, leading manufacturers to introduce ultra-thin filter designs. Vignetting becomes more pronounced as you stop down the lens aperture, so using the depth of field preview on your camera will alert you to serious vignetting.

The cure is to physically hold larger filters (bigger than the lens diameter) in front of the lens or buy a modular filter system big enough to stop the problem, such as the 100mm rectangular filter systems available from companies like Lee or Cokin.

TIP
If you are having problems with vignetting when using a screw-type filter, a quick fix is to take it out of its brass mount and hand-hold the filter in front of the lens. Make sure your fingers don't get in the way, and don't drop it. Put a camera bag under the lens just in case so it has a soft landing.

Below The difference when a polarizer is fitted is graphically demonstrated in this sunrise shot. The sun was rising to the right so the sky polarized perfectly. The entire shot is more deeply color-saturated, as glare has been eliminated, and benefits from a boost in clarity.

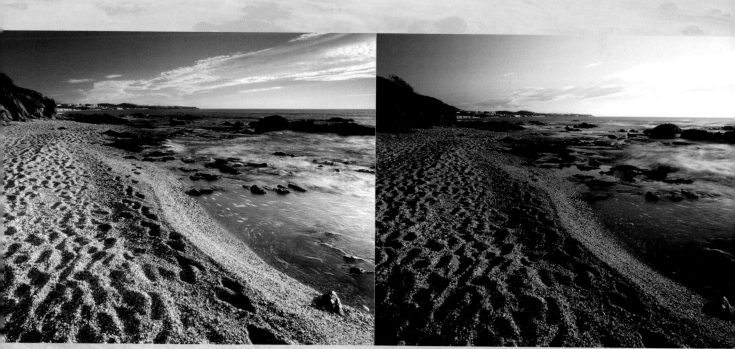

Without Polarizer

With Polarizer

Using **lens filters**

Gray graduate

Just as important as the rectangular filter systems (see page 31) is the gray grad, which can be used to balance the dark and bright areas of a scene—typically land and sky—to get a correct exposure across the entire picture. The top half is a neutral density gray color that gradually fades to clear at the bottom. Skies are usually brighter by several stops, and without a filter the sky would be overexposed or the land underexposed. The gray grad helps to balance the exposure of the two halves to achieve a perfectly exposed shot. It is best to take a reading from the land or darker area, and then place the filter over the brighter area. Use manual exposure settings for best results. Grads come in different strengths, typically 0.3, 0.6, and 0.9, which is the equivalent of one, two, and three stops.

Many night shots can be successfully taken without a gray grad, as you have to wait for the sky color to darken anyway. However, sunsets and dusk shots are often better with a graduate filter to balance the land and sky.

Neutral density filter

This is similar to a graduate, but, thanks to a neutral density filter, the density is uniform across the entire filter. Its effect is to simply reduce light levels without affecting color so that longer shutter speeds can be employed. Longer shutter speeds can also be used to creatively blur water or other moving objects such as people or cars. This filter is especially necessary when shutter speeds are still too fast (even with a small aperture) or when you need a large aperture in brighter light for shallow depth of field effects.

UV—Ultraviolet filter

This is one screw-in filter that is useful, as it protects your front lens element from dust and dirt, which can cause scratches that will ruin the lens. It also removes excess UV light, which can cause pictures to go blue, especially in high-altitude mountain areas.

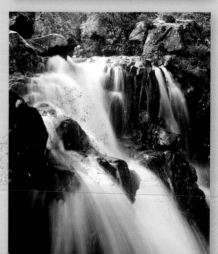

Top and Center Here I used a gray grad to stop the sky over-exposing. I also added a blue grad filter to add more color to the top of the sky.

Right A two-stop neutral density filter was used to lengthen the exposure enough to blur water. It took the exposure from half a second to two seconds.

Soft focus filter

A soft focus filter helps to remove hard edges in shots and is especially good for portraits where skin blemishes are reduced. The main aim is to create a dreamy or romantic atmosphere to the shot. This can be done in Photoshop, but the effects are not entirely the same. There are many types on the market and they come in a variety of strengths, but you can easily create your own. Try Vaseline or nylon stockings for a classic effect. Do not smear Vaseline directly onto your front lens element, but use a cheap UV filter or clear square plastic filter as a base. Wide apertures and slight overexposure work best, especially when the subject is backlit against a dark background—the highlights tend to bleed into the shadows, creating the classic halo effect. You can control and reduce the effect by using a smaller aperture.

Starburst filter and diffractors

Starburst filters and diffractors can be interesting when used for night shots with lots of small lights in the shot, but the effect tends to look over the top and tacky, especially with the cheaper filters, which produce a garish effect. However, a carefully chosen filter can produce a nice, subtle effect that you will actually want to use. Some lenses use lots of blades in an aperture design and these can create their own star highlights. Nikon lenses are particularly noted for this effect. Using a small aperture on any lens should create a star effect of some kind, or try creating your own starburst by scratching fine lines onto a clear plastic filter.

Diffractors create a colored abstract rainbow effect. It works in a few instances, but to be honest it's probably one to avoid. Buy one from a second-hand bargain box if you really must try one!

Below This tree was strongly backlit. With soft focus, the highlights have spread into the shadows to give an interesting graphic effect.

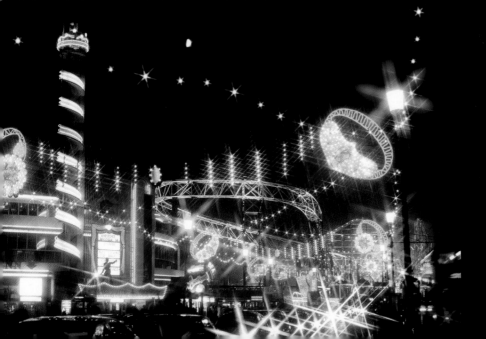

TIP

It is important to keep your filters clean and scratch-free or they will cause flare and image softening. Use a soft lint-free or microfiber cloth and follow the manufacturer's directions. Plastic filters are especially prone to scratches, so treat them with great care and repack them after use.

Left I used a star filter made by Cokin for this shot. They come in several styles, giving four or more flares to each point of light.

ISO settings and digital noise

Noise is the effect of image degradation caused by the inability of the sensor to process image data in low-light conditions. It's a pattern of dots created during exposure and it's similar to the grain effect of fast ISO high-speed films. Contrast is lowered, as is detail, and the shot loses clarity. The effect increases as the ISO setting is increased. During long exposures, an even less attractive form appears: random colored dots, appearing most strongly in the shadow areas. This affects the small sensors of compacts significantly more so than it does the larger sensors of digital SLRs, another point in favor of the latter. If you wish to avoid noise, choosing the correct ISO setting is crucial.

Film vs. digital ISO

In a film camera, the sensitivity of the film is measured using the ISO standard (sometimes known as ASA). A slow film has an ISO of 100, a medium speed film an ISO of 400, and a fast film 1600 ISO. The faster the film, the grainier it becomes—this has always been the compromise you have to make with film. Shooting handheld in low light means fast film, particularly if you need faster shutter speeds for freezing the action in sports photography. Many photographers have also used the soft contrast and grain effects of fast films to their advantage to create beautiful, impressionistic images.

Even though a digital camera replaces the film emulsion with a digital light sensor, the same ISO settings are used. As you can't just swap one sensor out for another, the only way the digital camera can boost sensitivity is by altering the signal strength. The higher the amplification, the more sensitive the camera becomes. However, this also means an increase in digital noise as the ISO is pushed upward. When you hear manufacturers quoting a high S/N (signal to noise ratio) rating, they mean the camera copes well at higher ISO settings.

Which ISO to choose

If you want beautiful, fine-grained images with no noise, you must choose the lowest ISO rating (usually 100 or 200 ISO). The downside is that slower speeds will often need a tripod to maintain sharpness. Luckily, most cameras can cope well at mid-range settings like 400 without any major loss in quality, and the higher spec cameras can go even higher, up to 800 ISO, with relatively little loss of quality. Beyond this, grain becomes intrusive. If you have no option, you have to choose this setting, but try opening up the aperture to its maximum first. You should run tests with your own camera to discover at which ISO setting you will be unhappy with the results.

In the past, photographers had to shoot using fast film to create lots of grain on purpose. This is no longer necessary, as you can add grain using the Noise Filter found in all software packages, and the result is usually more attractive. For this reason, you should always try to shoot at the slowest ISO setting. You can always add grain, but it's hard to remove it entirely.

Some more sophisticated cameras try employing a noise reduction function to limit the negative effects of noise. This is usually accessed via the LCD menu settings, and while it often adds on more processing time, it is worth the extra few seconds for the added quality. Software can also reduce noise (see page 142).

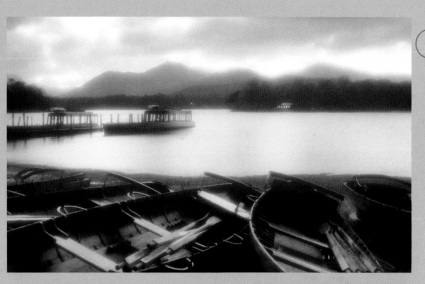

Left Here you can see the effect of noise as the ISO is changed from a slow ISO 200 all the way up to ISO 1600. Detail is lost and grain increases. The contrast also becomes softer. Color becomes less saturated, but this can be restored later on, using the Hue/ Saturation command.

Top This image was deliberately exposed using ISO 400 to add a little grain and lose some detail. A soft focus filter was added to create the dreamy atmospheric effect. This technique is also very well suited to close up portraits.

Above Shot at ISO 400, the grain has added to the shot, but one side effect is the loss of contrast and color saturation. In some cases, this is perfect for the shot, but one strength of digital is the ability to fine-tune the color and contrast. Here I boosted both in Photoshop to give a stronger impact to the poppies.

Color temperature

The perceived color of an object is dependent on the lighting conditions at the time, including the height of the sun, the surroundings and atmospheric conditions while outside, and the properties of any artificial light and the color of any reflective surfaces while inside. The color temperature of an object can be measured using the camera's built-in color sensor light meter, and this information is used by the Auto White Balance function. You can also usually make a manual selection or take a reading.

Kelvin measurement

The color of light is measured in units called Kelvin, a scale based on a black piece of metal being warmed up: as the temperature rises, the color changes from red to yellow to white to blue. The color temperature of midday is 5,000–5,500K and is the temperature at which a white object in your photograph will appear pure white. Lower the color temperature to about 3,000K, and the white object will appear warmer as the color temperature becomes redder. This is typical of sunsets and tungsten interior lighting situations. Make the color temperature higher, and it will make the white object bluer or cooler in color. You would need to find a mountain, snow or, clear blue sky (which will reflect blue light back) to appreciate higher color temperature situations of 7,000–10,000K. Mountain air is thinner and cleaner than at sea level, so more short blue light waves are present.

Human perception of color temperature

The human brain is very adept at neutralizing color casts in an image it is seeing, compensating for them to see a more natural, daylight-balanced view. Because of this you don't notice the green color cast of fluorescent lighting or the orange color cast of tungsten lights when working in an office because you are surrounded by the light source. Move outside and look back indoors and you will see the color cast straightaway.

Cameras don't have sophisticated brains, so they have to adjust the color cast using the White Balance controls to maintain a neutral feel. Without this control, the shot would take on the garish green or orange color cast.

Far left This example shows the way color temperature works in the real world. It was shot moments after sunrise, and the shallow angle of the sun has left the ripples partially shaded. The warm sunrise gives a reddish color cast, yet the shadows remain blue (they are unaffected by the sunlight).

Left Buildings bathed in late afternoon sun look glorious and come alive. The low angle brings out texture and the warm color gives the image a fabulous, healthy glow.

Light and color

Light changes its color throughout the day and you can take advantage of this to create different types of atmosphere in your photography. Sunsets and sunrises emit red and orange light, which is at the lower part of the temperature scale. Interiors shot at night using tungsten will also be warm and inviting. Use candlelight for the warmest effect possible. Shooting on an overcast day will lead to a color temperature of about 6,000K which will give a distinct blue effect. It is possible to correct colors—for example, you can add the opposite blue color to a tungsten lit room to make the whites appear neutral. You can also add a color cast to mimic a sunset by placing an orange filter over the lens, using the Shade White Balance setting (adds orange/red), or using the color controls in Photoshop.

Night shots take on the most exciting color as the sky darkens and you get a mix of different vibrant artificial colors.

Above These two shots show the benefit of waiting a few hours for the sun to go down.

Left Shot 15 minutes after sunset, the sky had gone dark and the color temperature had turned distinctly blue. A gray grad filter was used to keep detail in the sky. The blue color was accentuated later in Photoshop.

Color temperature—artificial

Artificial light sources are a nuisance for architectural photographers, who have to correct any strange color casts, but for landscape photographers they add loads of wonderful colors that clash and create exciting images. Don't fight the colors—go with the flow.

Most of the time you should leave color casts alone, as they often inject atmosphere into a shot. The secret is to know when you should correct them. This will depend on the image you are shooting and what it will be used for. The worst color casts occur indoors, where there is less daylight to dilute the cast. Shooting outdoors will yield a more favorable mix of colors, as the ambient daylight is often the dominant light source until very late dusk.

I would usually correct fluorescent lighting, which gives a ghastly green cast to images and makes people look sick and unhealthy—go to your camera's menus and choose the Fluorescent white balance setting. This can be fine-tuned in camera, but generally will give a good enough result, which you can always correct later in Photoshop. More advanced cameras offer several fluorescent settings, as such tubes come in a variety of designs, each with their own particular cast.

In this image the mercury vapor lights have cast an eerie green glow to the building. It works well because it is contrasted with the dramatic sunset.

If you think there is a color cast in your scene, ask yourself if it adds or detracts from the image. Take some test shots and look at your LCD display if you're not sure. Tungsten light can add warmth to a shot, and this might be perfect for the mood you are trying to create. People often associate orange colors with a warm cozy atmosphere. Rules are there to be broken and if you like a particular color cast, leave it uncorrected.

In many cases you can dilute the cast on the computer if it is too strong. The RAW plug-in found in Adobe Photoshop has excellent options to help remove color casts, and Photoshop has an armory of resources that work with non-RAW images.

TIP

Don't get lazy wih your night photography! A fast ISO rating does not excuse you from doing the job properly with a tripod. A slow ISO rating will reveal much more detail, especially if you wish to enlarge your images beyond 7x5". A tripod will also enable you to review the composition and tweak it if necessary.

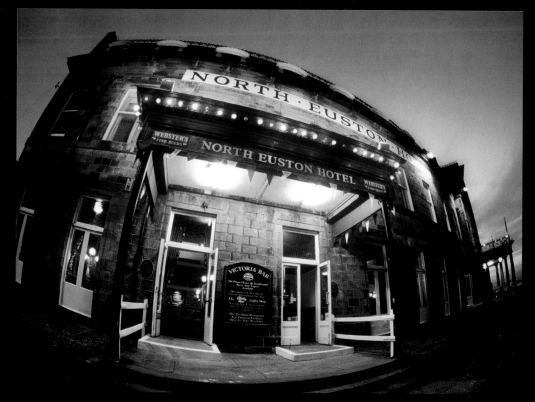

This hotel has just about every light source going! The fluorescent doorway glows green and contrasts well against the orange tungsten lights. This is a perfect example of why color casts can be successfully left to their own devices.

The **white balance** control

To get perfectly corrected colors without any color casts, professional photographers have, until recently, used a sophisticated and very expensive color light meter and a large collection of finely graded color correction filters. This system alone could have set you back serious money. With digital photography you have two new, quicker, and cheaper ways of correcting unwanted casts: in camera or in Photoshop.

In-camera color correction is possible using the white balance settings. More sophisticated professional cameras will have much better and more in-depth controls than smaller compacts, but even smaller compacts will have a selection of different settings to choose from. The color temperature of an object is measured using the camera's color sensor, and in Auto WB mode, it automatically adjusts the colors to produce a more natural color balance. However, auto is only one of several settings you can choose from:

Incandescent Use this setting when shooting under tungsten lighting. It covers the color temperature when it is about 3,000K, and adds more blue to compensate for the tungsten cast.

Fluorescent Use this setting under fluorescent lighting. It covers the color temperature at about the 4,200K mark and adds magenta/red.

Direct sunlight Use this setting under normal direct sunlight conditions when the color temperature is 5,200K.

Flash Use with your manufacturer's flash gun, which emits a color temperature of 5,400K. This setting adds slightly more red.

Cloudy Use this in daylight conditions with overcast skies. It covers the color temperature at around 6,000K, and adds more orange/red.

Shade Use in daylight conditions when the subject is under shade. Shade has a color temperature of about 8,000K, so this setting adds more orange/red.

Preset Use this with a gray or white card to take a manual color temperature reading.

Many top-end cameras can fine-tune the color temperature settings by shifting the color up or down in increments of one.

DIY COLOR CORRECTION

Try using the preset mode to get perfect color correction. Essentially, this works in the same way as using a color meter to calculate the necessary color correction to create a neutrally balanced shot. Only more sophisticated camera models will have this option in the White Balance menu. The exact method may differ from camera to camera, but it shouldn't be too different on most prosumer models or digital SLRs.

Firstly, place a white or gray card in the light source you want to be neutral. In the Preset menu, choose measure or rotate the dial to Pre while holding down the White Balance button.

Now briefly release the WB button and press again until the PRE icon flashes. Frame the white/gray card and press the shutter release button. The neutral color of the card will enable the camera to create a WB correction for that light source. If it produces an acceptable result, "Good" appears in the LCD control panel. You can now stay in the Preset mode until you have finished shooting in that particular light source.

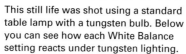

This still life was shot using a standard table lamp with a tungsten bulb. Below you can see how each White Balance setting reacts under tungsten lighting.

1 The auto setting has done a good job and nearly corrected the image.

2 Using the DIY technique, the WB Preset reproduces the color perfectly, showing how accurate this method is.

3 Using the WB Incandescent setting, the color balance has been reproduced quite well with a slight warmth that some would find pleasing.

4 The WB Fluorescent setting adds a magenta cast. This makes sense, as magenta is used to cancel the green color cast of fluorescent lights.

5 The WB Direct Sunlight setting is used in normal midday sunlight and is similar to the color balance of daylight film. It has gone a very warm orange color due to the tungsten light.

6 The WB Flash setting gives a slightly warmer setting than Direct Sunlight to counteract the slightly blue quality of electronic flash.

7 The color shift of the WB Cloudy setting from the Flash setting is about 600K, which has given a slightly warmer effect. This would normally be used to cancel the bluish cast under cloudy conditions.

8 There is a more pronounced shift of 2,000K between Cloudy and Shade, so the warm effect is more pronounced.

Slow **shutter speeds**

One of photography's most beautiful and artistic effects can happen by accident when you use too long a shutter speed. Anything moving will record as a blur. This technique can be refined to give an ethereal atmosphere to many subjects, and it's easier to pull off in low-light conditions than it is in bright daylight.

The balance between gentle motion blur and overall sharpness is often the key to this kind of shot. If you let the shot blur completely, you would have no idea what the original subject was. The best way to achieve this balance is to shoot several frames at different shutter speeds. In manual mode, alter the aperture to increase or decrease the shutter speed and then readjust the shutter speed dial accordingly. Alternatively, choose shutter priority mode and move only the shutter speed dial.

Isolating the subject

If your image has no other defined area of sharpness, it might be best to get in close to your chosen subject. If, say, you want to blur cars in the foreground while keeping the building behind in sharp focus, then the effect will work from a distance. Without the building, you need to choose a tight crop—this maximizes the impact, keeps the viewer focused on your subject, and enables them to work out what it is.

Below Here the camera was deliberately moved during the four-second exposure (even though it was sitting on a tripod). This adds to the overall feeling of movement.

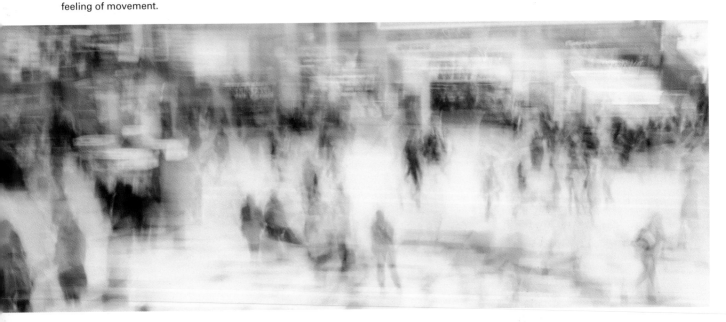

Above An 80mm lens was used to keep the waterfall large within the frame. The exposure was eight seconds at f11, shot at dusk in low light. Fast-flowing waterfalls can look stunning when the slow shutter speed technique is used. Aim to get a shutter speed of one second if possible, but experiment with different times to vary the effect.

Left Top The 80mm lens isolates the water from amongst the darker rocks in the foreground. This has placed emphasis on the water as the main subject. A slow shutter speed of eight seconds at f11 was used on this dark gray day to make the water blur.

Left Here a 400mm lens was used to get a tight crop on the actual waterfall. Shot in low light in winter, the exposure was five seconds at f11.

Slow **shutter speeds**

Neutral density filter

On bright mornings, you might not actually get a slow enough shutter speed to cause blur to your subject. There are several ways around this and you may have to employ all of them in some instances.

Firstly, you can choose a very small aperture; some lenses will go down to f32. This can cause problems if you want to maintain a shallow depth of field—at f32, everything will be in focus from front to back—but to get around this you can use a neutral density filter. The filter is one continuously toned dark gray color, which means it won't give a color cast to your shot, and by placing it in front of your lens you get a reduction in the amount of light, which means you have to increase the shutter speed to compensate.

It is also possible to use a polarizer to increase the shutter speed by two stops. The only drawback is that you need to polarize the light to get two stops, which may not be the best thing for the shot. You can get one stop density without rotating the filter.

Filters come in a variety of different strengths from 0.3 to 6.0, but the most useful are in the 0.6 to 1.8 range. The 0.6 filter has a filter factor of 4 and reduces the light by two stops, the 0.9 has a filter factor of 8 and a three-stop reduction, and finally the 1.8 a factor of 64 and a six-stop reduction. Filter factors double for each stop of light loss.

Filter factor	f-stop reduction	Density
2	1	0.3
4	2	0.6
8	3	0.9
64	6	1.8
1000	10	3.0
10000	13	4.0
1000000	20	6.0

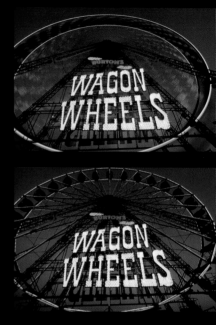

Above These two examples show how a subject can be transformed by letting it move and blur during the exposure. You may have to wait for the right moment before firing the shutter. Here the wheel kept stopping to let people on or off, and this had to be taken into account.

Right Top The camera was left in the traditional static position so that the background remains sharp while all the car lights are blurred into a continuous streak. Exposure was 45 seconds at F16. I used a black card with the bulb "B" setting so that I could cover the lens during quiet periods between lights changing. This helped build up the blurred lights.

Right and far right By panning the camera during exposure, you create a dynamic image full of blur and action to both subject and background.

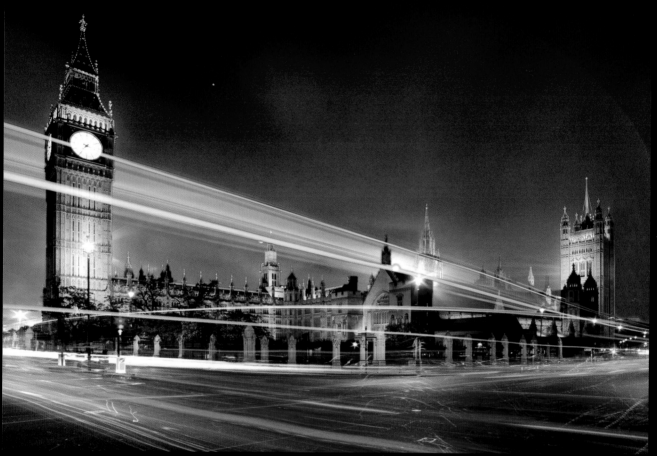

Analyzing images

One of the advantages of digital photography is the ability to review images as soon as you have taken the shot, giving you some idea of whether the shot is correctly exposed, framed, and focused. However, it can be very difficult to see the LCD screen properly, especially in bright sunny conditions or when the screen is viewed at an angle, so you will also need a more accurate way of assessing the image. The histogram setting found on most quality cameras enables you to do so with more reliable results.

What is a histogram?

The in-camera histogram is a simplified version of the one found in most image-editing software packages (learning to read one will help you work with the other.) It shows the exposure or range of tones as digital information. The horizontal axis shows the tonal range, with the darkest (shadows) to the left, average tones (midtones) in the middle, and light tones (highlights) to the right. The vertical axis shows how many pixels are allocated to each area. The histogram overlays the image and gives you a way of checking you have captured a full range of tones.

TIP

To view images on the LCD screen, try placing a pullover or jacket over your head so you can view the screen in darkness. It's reminiscent of using a dark cloth with a large format film camera.

OVEREXPOSURE

Here the histogram shows no shadow detail on the left-hand side and the image is washed out. The tonal range starts only near to the middle of the horizontal axis. In effect, the entire tonal range has shifted to the right.

Depth of field

Depth of field is the zone
of sharpness found in a
photograph, and this is
dependent on which aperture
and focal length you choose.
It is also dependent on the
magnification of the subject. A
wide-angle lens has a naturally
good depth of field because the
lens is designed to take in a
wide angle of view. A telephoto
lens uses a magnified part of
the wide-angle lens (imagine
it has zoomed in from 28mm
to 300mm), which means the
depth of field will become
shallower. The greater the
magnification, the shallower the
depth of field, and this is also
true for macro lenses where
image magnification is high.

It is important to understand depth of field so you can use it correctly. Some images require front to back sharpness while others need a shallow depth of field to create the right image.

Getting maximum depth of field

The only way to control depth of field at a given magnification is to alter the aperture. The wider the aperture, the shallower the depth of field. Only by stopping down the aperture to, say, f11 do you begin to get greater depth of field. Wide-angle lenses require only f5.6 or f8 to get a good depth of field where the subject is some distance away, but if using a tripod always use a small aperture. The closer the subject, the smaller the aperture needs to be to maintain depth of field.

Hyperfocal focusing

This relies on your lens having a depth of field scale, which some modern designs unfortunately do not have. Having chosen an aperture of f11, you now alter the focusing ring, in manual mode, so that the infinity symbol (∞) above the red dot is above your chosen aperture of f11.The depth of field has now increased from 9ft–infinity to 5ft–infinity. This is critical when your subject is within this close range.

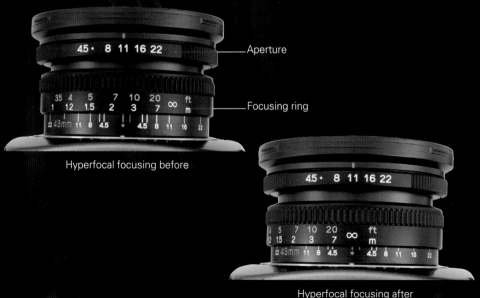

Aperture

Focusing ring

Hyperfocal focusing before

Hyperfocal focusing after

Dew on grass

Sensor size

The smaller the image-taking area (i.e. the sensor) becomes, the greater the depth of field, so digital cameras that use small sensors have a naturally greater depth of field compared to larger formats. This makes them ideal for macro photography.

Creative depth of field

You don't always have to have a great depth of field, as some subjects suit a shallow depth of field. Use larger apertures and longer focal lengths to achieve this. In this image I used a 90mm macro lens at its widest aperture of f3.5 to capture the dew on this blade of grass. The low angle of the sun has created pools of darkness, which add drama to the shot.

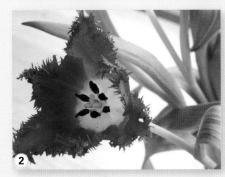

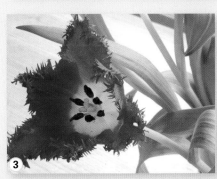

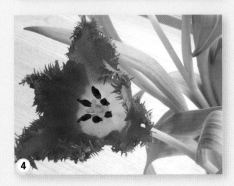

APERTURE

1 This was shot at the widest aperture of this 28–80mm zoom lens (f5.3 with a $1/8$ sec exposure), and you can see the depth of field is very shallow. Shooting close up has exaggerated the effect because the subject is magnified. Shooting "wide open" lets you create very interesting effects where you deliberately place emphasis on one part of the shot only. It has added a nice artistic feel.

2 Even when the aperture has been stopped down to f11$1/2$ (f13), the depth of field is still not good enough for complete sharpness. These tulips were shot indoors, so wind was not an issue, but outdoors the slightest breeze causes blur at a shutter speed of 1$1/2$ seconds. When shooting anything that moves there is always a compromise between shutter speed and depth of field (aperture).

3 At f27, the exposure was three seconds and there is a good depth of field that would be adequate for many macro situations. Shooting wide angle scenes like landscapes would require an aperture of about f8 or f11 for good front to back sharpness. With its high magnification, macro photography often requires very small apertures for successful shots.

4 By the time the aperture has been closed to f38 the exposure has increased dramatically to eight seconds. Depth of field has also increased to the point where the entire picture is sharp from front to back.

Analyzing images

One of the advantages of digital photography is the ability to review images as soon as you have taken the shot, giving you some idea of whether the shot is correctly exposed, framed, and focused. However, it can be very difficult to see the LCD screen properly, especially in bright sunny conditions or when the screen is viewed at an angle, so you will also need a more accurate way of assessing the image. The histogram setting found on most quality cameras enables you to do so with more reliable results.

What is a histogram?

The in-camera histogram is a simplified version of the one found in most image-editing software packages (learning to read one will help you work with the other.) It shows the exposure or range of tones as digital information. The horizontal axis shows the tonal range, with the darkest (shadows) to the left, average tones (midtones) in the middle, and light tones (highlights) to the right. The vertical axis shows how many pixels are allocated to each area. The histogram overlays the image and gives you a way of checking you have captured a full range of tones.

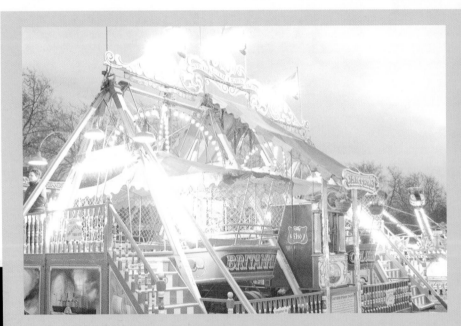

TIP

To view images on the LCD screen, try placing a pullover or jacket over your head so you can view the screen in darkness. It's reminiscent of using a dark cloth with a large format film camera.

OVEREXPOSURE

Here the histogram shows no shadow detail on the left-hand side and the image is washed out. The tonal range starts only near to the middle of the horizontal axis. In effect, the entire tonal range has shifted to the right.

Checking your highlights

LCD screens give an instant representation of what you have just taken, but they're not ideal if you need to see how the finest highlight and shadow detail has been treated. Digital cameras are notorious for losing detail, especially in the highlights, which can easily burn out in night shots. Once the information has gone, you cannot retrieve it later in Photoshop. To overcome this problem, many LCD displays show the missing highlights as black areas that flash. Fuji's new CCD design remedies this by using small highlight sensors as well as standard sensors to capture delicate detail. The only other method is to use a gray grad filter or take several exposures and bracket the results so you can merge them later in Photoshop.

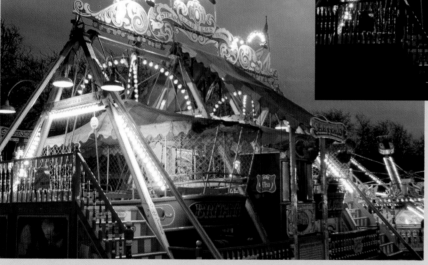

CORRECT EXPOSURE

The histogram displays detail in all areas along the horizontal axis. This means there is a good distribution of tone across the entire image, resulting in a correctly exposed image full of detail in shadows, midtones, and highlights.

UNDEREXPOSURE

The histogram shows no highlight detail and midtones have been squashed up, resulting in severe underexposure. The entire tonal range has shifted left to the dark tone end.

3

Outdoor Low-Light
Photography

Photographing at **dawn**

Dawn is a beautiful and quiet time to take pictures. The world is still slumbering, and the weather is often clear and still. The biggest challenge you will face is getting out of bed at four o'clock in the morning during the summer months.

The color temperature of dawn light is very cold and blue, as the sun has yet to rise, and only the short blue waves are in abundance. The light is soft and shadowless, as it is only reflected off the sky or clouds, which acts like a giant diffuser. Clear blue skies also reflect extra blue light back onto the land. White-colored objects such as buildings often have a blue color cast to them. Deep shadows will be blue as the sun rises, which can create some lovely color contrasts against the warm colors of the sun. Colors in general are often muted and more monochromatic, especially with the addition of mist. It is often a good time for commercial photographers to shoot their products on location—especially cars—as there are no hot spots ruining the flow of the shape.

The weather is often calm, quiet, and tranquil. This calmness is great for shooting water, especially lakes, as you get shouldn't get many ripples. In the right conditions, perfect mirror reflections are possible.

Early morning mist adds to the atmospheric impact of dawn shots. Cool, windy nights, on the other hand, will help to clear the air—pollutants are significantly reduced, leading to the crystal clarity often present in shots taken at dawn.

A 300mm telephoto was used with a 2x converter, making a whopping 600mm lens. The camera was weighed down with a camera bag on a sturdy tripod to minimize camera shake. The slightest nudge, even from a finger, will cause problems, so a cable release was also used. No filters were needed for this shot.

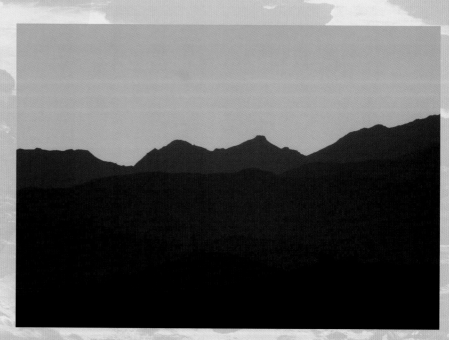

Top This was shot on the coast of Southern Spain near Fuengirola, and the beautiful colors were enhanced slightly with a warm-up filter. This can be done on camera or at home on the computer. It can be difficult to get the exact match for a favorite warm-up. Here a Lee Coral filter was used.

Center The cold color of dawn was enhanced in Photoshop, using the Color Balance command to add a touch of blue. A wide angle lens was used and the image was cropped afterward.

Bottom The sunrise was quite fiery and dramatic on this occasion. Plenty of broken cloud is usually a good sign that a decent sky will happen. I shot using a wide-angle lens to create foreground interest with the dramatic rocks.

TIP
It is best to get all your gear ready the night before so you can dash out without having to worry about every little item at four o'clock in the morning!

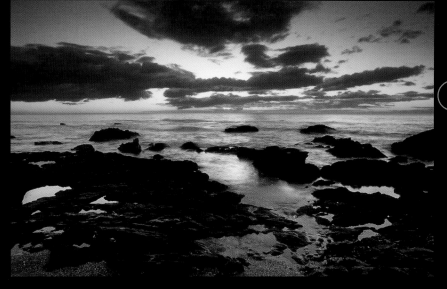

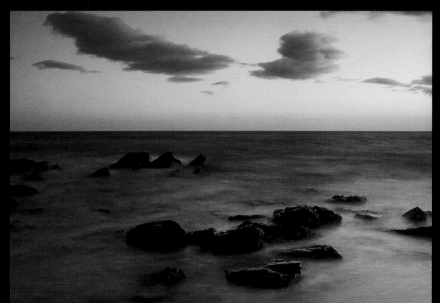

Photographing at **sunrise**

Pre-dawn is obliterated as soon as the sun rises above the horizon. It's like a bomb going off—the effect on the landscape is so sudden and extreme. Brilliant golden light pours across the land into every nook and cranny, but because the sun is so low in the sky it will also leave long shadows, creating a fantastic three-dimensional textured effect. Sunrise brings out every ounce of texture possible as the sunlight skims over the surface of objects. Shadows will be at their longest and some great graphic effects can be achieved when you include these in the foreground.

Sunrise will last only about 20 minutes before its magic has given way to regular daylight, and as the quality of light changes by the minute it is no good arriving unprepared—you will run the risk of missing the best part of the show! It pays dividends to arrive earlier, scout around for the best viewpoint, and have your tripod set up in position so you are ready to capture the quality of light as it changes. The very first rays of light are often the best. You can get an intense red color that may last for only one or two shots.

If you don't know a location well then a compass will help you determine the approximate direction in which the sun will rise, depending on the time of year. Use this information to your advantage, but you may still have to guess the exact position of a sunrise unless you have visited the area many times. Keep an eye out for the dawn glow, which should give a clue as to where the sun will pop up. The sun will appear from the brightest part of it.

The best thing about sunrises is that you will probably be the only person around. You won't get any people in the shot ruining it or coming up to you and asking "What are you doing?" You will find the opposite is true for sunsets, especially at popular sunset viewing hot spots.

Sunrise is also a great time to photograph people, as the natural warmth of the sunlight and the angle of lighting create the perfect conditions. Many shots benefit from the addition of a reflector to bounce light back into the model's face and remove any sign of harsh shadows.

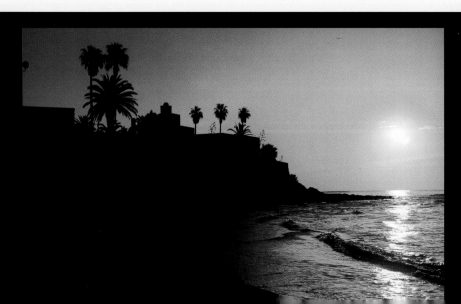

Left I used a pink graduated filter on top of a warm-up filter to add some color and detail to a rather bland and featureless sky. This effect can be done later on, but works better when recreated in camera.

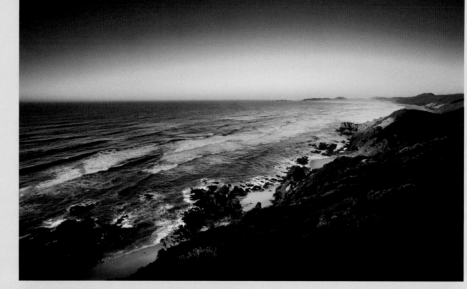

Right These two examples show the difference between dawn and sunrise; a matter of only ten minutes separates the shots. The different feel in each shot is quite amazing.

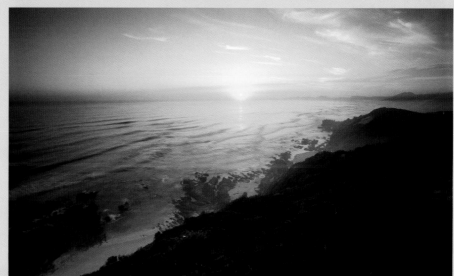

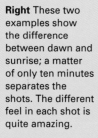

Above Shooting with a 300mm lens at f8, I patiently waited for the boat to enter the sun's reflection in the sea. I took shots before and after, but it cries out for symmetry. I metered to the side of the sun with a spot meter.

Right Isolating a single element, in this case a tree, can create stunning yet simple images. Quite often, less is more! The shafts of light were added in Photoshop (see page 138).

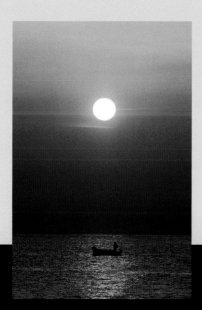

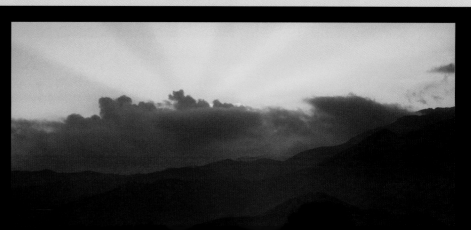

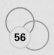

Photographing at **sunset**

The Golden Hour

The sunset is the finale of the day—like a firework display, the sun likes to bow out with a display of glorious pyrotechnics! This is especially true when there is plenty of broken cloud for the light to bounce off. Before this point is reached, you should be taking advantage of the "Golden Hour" when the setting sun bathes the land in warm sunlight. The quality of light is again similar to the sunrise: strong and directional, creating plenty of long shadows and texture. The mist that often shrouds morning shots has disappeared but may be replaced with a haziness caused by atmospheric pollution. You can often tell what time a shot has been taken from this.

The color temperature is often warmer at sunset, as the short blue waves have been overrun by the longer red waves, causing the classic orangey red colors. Heat haze and pollution have had all day to develop, so you don't get that crystal clear clarity often found with sunrises—particularly in more industrial or built-up areas.

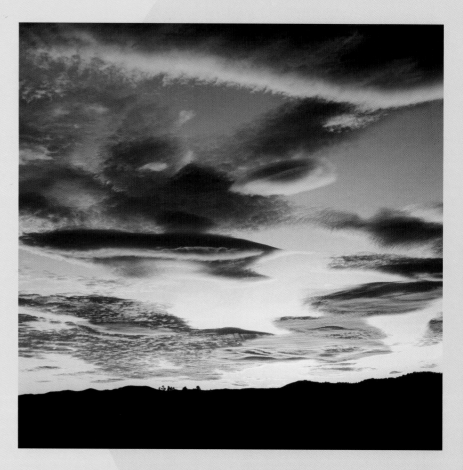

Guessing the final resting place of the sun on the horizon is much easier than at sunrise because you can watch its path as it goes down. This extra time makes it easier to get your composition right. Remember, the biggest obstacle will always be the weather, which can quickly ruin any attempt to shoot a decent sunrise or sunset. It is especially frustrating when it clouds over at the last minute, but put it down to experience and try again another day. Dogged determination will get you memorable shots that quickly make you forget about the failures.

Broken clouds often reflect a whole range of colors, from fiery reds to subtle pinks as the sun sets, which can often lead to the most dramatic sunset conditions, especially after a storm. It's worth venturing out in stormy weather conditions in the hope that it will break before the end of the day.

White balance

Change the white balance setting to Direct Sunlight to maintain the warm sunset or sunrise colors faithfully. If you leave the setting on Auto, your camera may try to correct the image and remove the colors to create a more neutral color balance. That's great for interiors, but not for sunsets!

Exposure

Photographing the sun, especially with a long telephoto lens, can be dangerous. If you have to squint to look at the sun with the naked eye, then you shouldn't even try with a telephoto. There are better ways. Some cameras have a depth of field preview button, which can be stopped down in conjunction with a small aperture to check the sun.

To take a meter reading, point the lens to the side of the sun so it isn't in the shot and, if possible, take a spot or center-weighted reading. Generally the aperture should be opened $1^1/2$ to two stops more than a reading taken with the sun in it. Alternatively, the shutter speed can be increased to compensate.

Subject matter

Sunset is the best time to shoot portraits, as the day has warmed up and everyone is more relaxed. The sun is at its best angle for side lighting and this produces a more flattering result than the harsh overhead light of midday. You can easily use a reflector to push extra light into the shadows for a more balanced image.

Shooting buildings can be a challenge, as some may be in complete shadow. Luckily, modern buildings that use lots of glass often reflect a great deal of light. If that's the case, spectacular results can be had.

Landscapes are at their best at the beginning and end of the day, so try to shoot at these times as much as possible to improve your photography. Of course, it is possible to get good shots at any time of day, but subject matter must be chosen more carefully. When the sun is high, you need to choose subjects that have a strong graphic impact. At sunset, the color of the sky will do more of the work for you, transforming even the least promising scene into something special, and a special scene into something amazing.

Opposite
This sunset shows how dramatic clouds can be when the sun reflects off them. Sunsets like this are payback for all the hard work you have to put in. A 35mm wide-angle lens captured the full scale and beauty perfectly.

Top right
The soft hazy sun has produced a lovely pastel study where the colors are muted and understated. A 400mm telephoto was used.

Center right
Dramatic shots of the sun setting over the sea can be taken anywhere in the world. A little extra contrast was added and the sea was made slightly bluer than in real life.

Bottom right
The low sun has created a dramatic effect where the background is lit up but the foreground is in shadow. To help, take a manual exposure reading for the foreground and place a gray-grad filter over the lens to cover the top half.

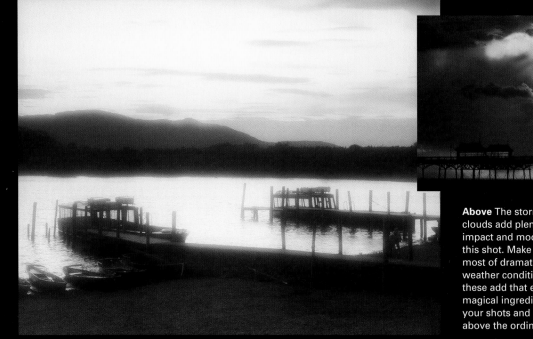

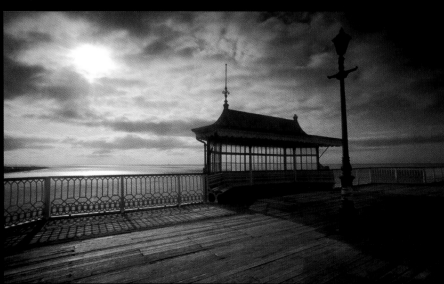

Above The stormy clouds add plenty of impact and mood to this shot. Make the most of dramatic weather conditions, as these add that extra magical ingredient to your shots and lift them above the ordinary.

Above Derwent in the Lake District, England was captured at sunset. Backlit images can be technically difficult, but with rewarding end results. Remember to overexpose and bracket like mad!

Right The strong shadows are caused by the low angle of the sun, while using a gray grad filter helps to maintain a balance in detail between the foreground and sky. Without the filter, the latter would have been washed out.

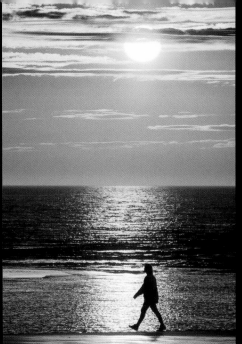

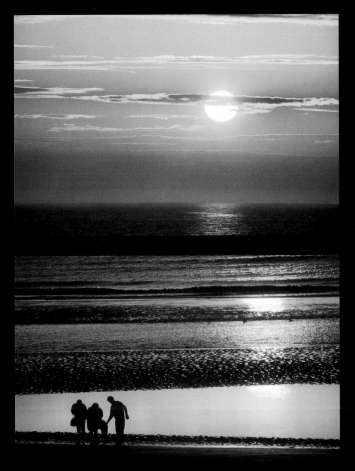

Left For this shot, taken with a 400mm telephoto lens, I positioned the family on the third for a more natural composition. A tripod is essential for such long telephoto work if the image is to be pin-sharp.

Above A classic sunset shot with a 400mm lens. Without the clouds, the shot would have been less dramatic.

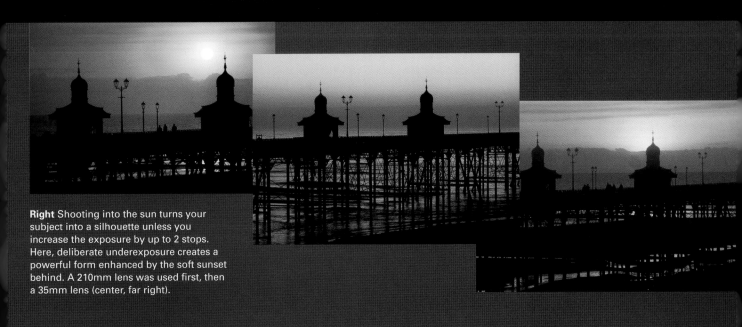

Right Shooting into the sun turns your subject into a silhouette unless you increase the exposure by up to 2 stops. Here, deliberate underexposure creates a powerful form enhanced by the soft sunset behind. A 210mm lens was used first, then a 35mm lens (center, far right).

Photographing at **dusk**

As the sunset fades, you enter the period known as dusk, where you are often rewarded with a beautiful warm afterglow as the sun disappears under the horizon. This is a similar time to the pre-dawn zone just before sunrise, but there are some notable differences in the quality of light. The color temperature is generally warmer, because any heat haze and pollution will have risen high in the atmosphere, helping to diffuse the cooler blue short lightwaves. This means sunsets are often warmer than sunrises. Mist is usually absent too— unless you're shooting in cold conditions, it appears only once the surface goes cold, after six to 12 hours without sun.

Quality of light

Just like dawn, you get a beautiful soft shadowless light that seems to glow at dusk because of the warmer color temperature. This is my favorite part of the day, as you can shoot four birds with one stone! Make the most of the different zones of light quality that occur over a three-hour period: the "Golden Hour" before sunset, sunset itself, then dusk or twilight for another 25 minutes before the inky black sky tells you it's truly night.

Urban or country

Shooting out in the countryside, you have less time at dusk to get your shots. The ambient light quickly fades to the point where areas not lit by street lights are too dark to shoot. Unless it's a full moon or you use a portable light source like flash, any exposures will be in minutes not seconds. Try using a gray grad filter to darken the sky. This allows for more exposure to the darker land. You could also try bracketing your shots and merge the best areas together using Photoshop.

Most successful dusk photography occurs in an urban environment, where street lighting keeps the subject matter properly illuminated. In such situations, keep shooting until the sky has gone pitch black.

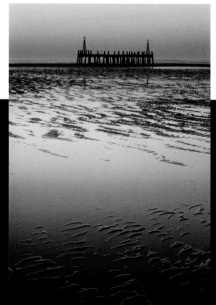

Right A polarizing filter can really make images glow. The reduction of glare lets the colors become really saturated, adding even more impact. Polarizers need two stops more light, so slow shutter speeds can be a problem, but you can use this to add a natural blur. This olive field in southern spain was shot with a 28mm lens at f11 for two seconds.

Far Right The soft light of dusk is perfect for subtle gradations of tone, as the water reflects what is happening in the sky. A telephoto makes the ruined pier larger in the background, thanks to perspective compression. A small aperture of f22 was used to maintain maximum depth of field.

Black and white

When the sky has gone black and there is no more color, you can still get some good shots if you turn them to black and white. Shoot in color, then use Photoshop to convert to black and white later (see page 146). Some subjects suit a black sky in color, but generally it is best to have a lovely deep blue sky, as it contrasts well with the orange tungsten lighting. It is also a good time to experiment with painting with light ideas (see page 72).

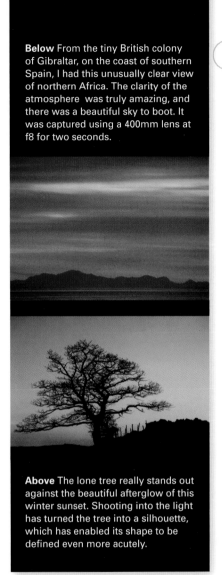

Below From the tiny British colony of Gibraltar, on the coast of southern Spain, I had this unusually clear view of northern Africa. The clarity of the atmosphere was truly amazing, and there was a beautiful sky to boot. It was captured using a 400mm lens at f8 for two seconds.

Above The lone tree really stands out against the beautiful afterglow of this winter sunset. Shooting into the light has turned the tree into a silhouette, which has enabled its shape to be defined even more acutely.

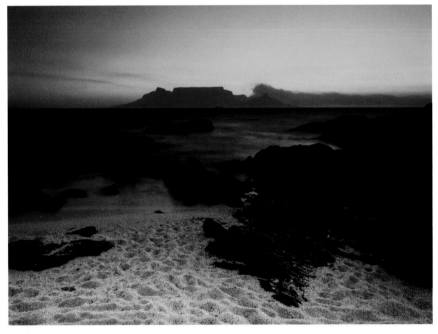

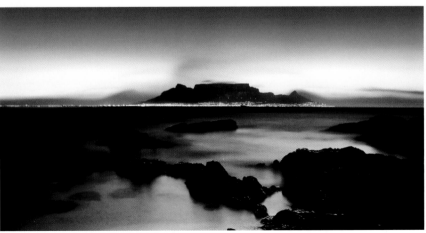

Above left This image was shot 20 minutes before the final version, below. The lights are not yet noticeable.

Left I shot Table Mountain, Cape Town from Bloubergstrand across the bay. The exposure was four minutes long and it was much darker in situ than the final image appears. It's always worth doing a few extra long exposures. You never know exactly what you will get, and in this case it produced a very memorable image, which is one of my favorites from my trip to South Africa.

Storms and bad weather

Some people chase storms because they offer the photographer a chance to get really exciting and dramatic pictures. Often you may start out with nice weather that can deteriorate during the day. Stick around. The clouds may break to give you that magical moment as the sun briefly shines on a stormy landscape, and when it does, you can be guaranteed to capture a dramatic fleeting moment, and a unique moment at that—each weather front is completely different.

Light takes on fascinating characteristics in stormy weather. It is bright yet often directional, as it streams from clouds as narrow rays. It can often be like several large spotlights trained on the land, and a stormy tumultuous sky full of textured clouds is always more exciting than an insipid blue featureless sky.

Rain can be difficult to photograph in, and is never a good mix with delicate camera electronics, but photographing just after a downpour can yield some great shots. This is especially true in the urban environment, where puddles of water can reflect all the bright lights of the city.

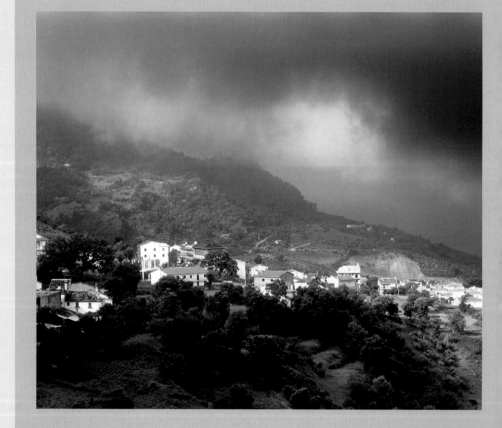

Right This picture, shot with a 100mm lens, is what stormy weather was made for. A pretty Spanish village cascading down a hillside in the Grazalema National Park is bathed in a brief moment of sunshine, setting off the dark stormy clouds.

TIP

One of the hardest things to overcome is a strong wind, as it can play havoc with camera shake, especially with long telephoto lenses. One tip is to weigh your tripod down with your camera bag or take a small empty bag and fill it with some stones. Place it over the base of the tripod to help add more stability.

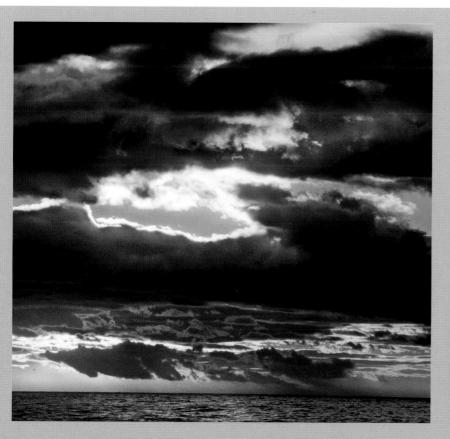

Above I knew the sun would appear from behind the storm front in a very narrow band of clear sky near the horizon. It was just a question of waiting, and I'm really glad I did! The autumnal colors just zing against the steel blue sky.

Left The clouds fortunately broke up on this blustery stormy day to create a dramatic finale.

Below Another example of stormy weather clearing at the end of the day. The rocks in the foreground help to lead the eye into the shot, and a slow shutter speed lets the water blur, creating an air of mystery.

Storms and bad weather

Shooting in stormy weather—or simply taking advantage of it when it appears—requires a certain ability to improvise and a willingness to face the weather head on. Obviously, you should always be concerned about your own safety and your equipment, but a little bit of daring can net you some great results.

The shot of Gummers How, Cumbria, England (see right), came about because I had walked up this hill on a fine winter's day with blue sky. As I came down, I became engulfed in a snowstorm that appeared out of nowhere. I managed a couple of shots before the snow became so bad I couldn't see more than a few feet in front of me. The resulting shot was quite dramatic. I stayed and grabbed the shot at a time when most people would have rushed back to their car, even if I did end up looking like a snowman!

At other times, it's all about speed. Time spent setting up a tripod or adjusting your focus can cost you the perfect shot. If you haven't got time to set up a support, use a faster lens hand-held and maintain a steady hand. Mother Nature rarely waits for those hesitating about wondering whether to shoot or not.

Below left The steel-gray sky sky acts as a perfect backdrop to this sunlit tree. As I drove by, the sun suddenly broke through and washed the landscape in warm late afternoon sunshine. At best, opportunities like this last for a few minutes, so quick reactions are paramount. I used a fast f1.8 50mm lens, hand-held to avoid wasting time with a tripod. Some sharpness at the edges has been lost due to the wide aperture, but moments later the entire landscape went back into a somber darkness.

Below You often get changeable weather high up in the mountains, and this storm rolled in, ruining my nice blue sky. The side lighting from a late afternoon sun has given the shot extra drama. A gray grad filter helped to darken the sky so detail wasn't lost.

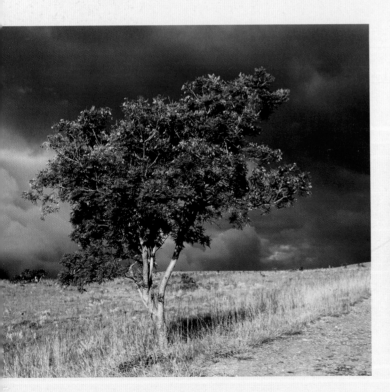

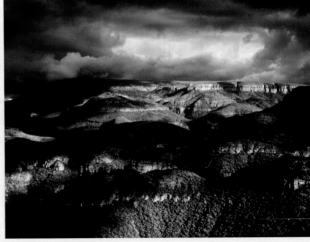

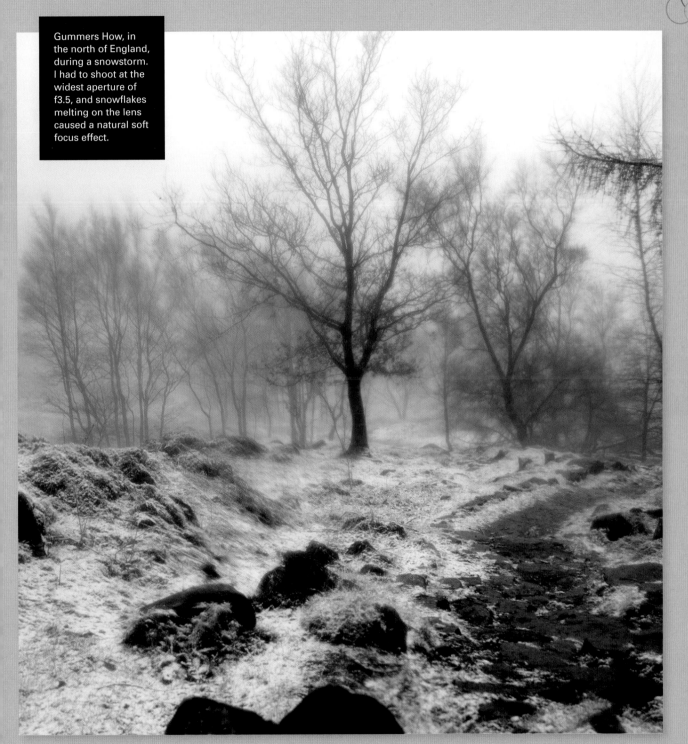

Gummers How, in the north of England, during a snowstorm. I had to shoot at the widest aperture of f3.5, and snowflakes melting on the lens caused a natural soft focus effect.

Fog and **mist**

Fog and mist will give an instant atmospheric quality to your shots if you are lucky enough to get caught out in some! You may think it is time to pack your bags and head for home, but good photographers will use unusual weather conditions to their advantage. They can transform the mundane into something new and exciting, or simply give a different slant to a familiar scene or object.

Fog and mist usually occurs in winter or cold conditions, but sea mists can happen in warmer weather too. Fog is generally much thicker than mist to the point where you can't even see your hand in front of your face. When it gets that thick, photography becomes pretty much impossible.

Mist, on the other hand, can be much thinner and more delicate. It tends to cling to the ground and recedes in strength as it gets higher; this makes it great for landscapes as you get to see more detail. Mist is more often to be found at the beginning or end of the day, especially before the sun has had time to burn it off. Once the sun has risen, the delicate mist will disappear very quickly, but thicker fog can linger all day long. It's particularly effective when photographing forests, as trees become less defined and image detail recedes at further distances. This creates zones of different definition, which can be particularly nice. The effect can be used on many different subjects, and it's especially effective when you want to isolate the subject from an ugly background.

Both mist and fog diffuse the light to varying degrees. Thicker fog will diffuse the light so much it creates a very soft, often directionless light source, even at midday. The thinner mist can create interesting lighting effects, and shafts of light can be created, adding mystery and drama to a shot when backlit with the sun. Colors often become muted, producing delicate pastel shades and monochromatic colors. Thick fog will tend to produce a bluer colder light source than mist, which can still retain the warmth of the sunrise.

Below This time, the sun was off to the right. It causes more flare, but this adds to the atmosphere of the shot, the foreground tree becoming a strong dark silhouette while the other trees grow softer and recede. Shot with a 200mm telephoto lens.

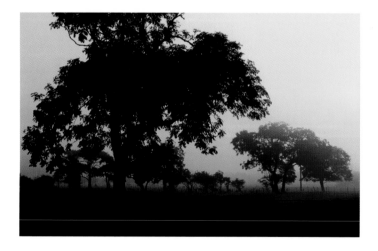

TIP
Although it may seem a strange notion, try to go out in many different weather conditions, as you can capture your subject in different ways and with different moods.

Using **flash** outdoors

Beginners associate flash with interior shots, quick photos, and portraits, but it becomes useful outdoors as a second light source to balance ambient lighting or add detail to night shots.

For these purposes, a camera's built-in flash has its drawbacks. Being fixed units, they can't be moved up or down for bounced flash, nor can they be placed to one side of the camera for more natural lighting effects. More importantly, they simply don't have the power output of bigger hand-held units, making these a necessity for more adventurous techniques.

Whichever flash system you use, you will have to adhere to the top flash sync speed of your camera. This is often $^{1}/_{250}$ sec, but some systems offer much faster sync speeds. If you use too fast a speed, half the frame will be missing from your exposure. Built-in flash units and larger dedicated detachable units have Through The Lens (TTL) capability for the most accurate exposure results, cutting off the flash when the correct exposure is reached. Manual flash guns don't do this, meaning more care must be taken when exposing.

Outdoor flash

You need to consider two exposure problems when using a manual flashgun—the background and the subject. Correct flash exposure is governed by aperture, not shutter speed, so first do a test to find the correct aperture. With TTL metering this is worked out for you, but you may want to override the auto in some instances. Switch to manual (or stay in TTL mode) and use the flash exposure compensation button on the camera (or flash LCD panel if a separate unit) to increase or decrease the flash output. You can test the correct exposure by trial and error via the LCD panel, or more accurately using a hand-held flash meter. Once you have the correct aperture, it stays the same if using the same power output and distance to subject.

Now take a meter reading for the background at the same aperture setting. This should give a balanced shot, but try bracketing in half stops above and below this setting—changing the aperture, not the shutter speed—just to be safe.

It's now time to think about shutter speed. This alters the amount of ambient light entering the camera, not the flash exposure. With the correct aperture for your flash set, you can use a faster shutter speed to deliberately darken the image for dramatic low-key images, or use a slower one to add more ambient light. For most low-light situations, you will probably want to use a slower shutter speed to increase the ambient exposure. Imagine you're shooting a person against a cityscape. The correct exposure might be eight seconds to record the buildings, but on Auto your camera may shoot at the default flash speed of $^{1}/_{125}$ only when the flash is used, resulting in a correctly exposed person but grossly underexposed cityscape. Switch to manual and increase the shutter speed yourself or use the Night Portrait mode, which will give a longer exposure in Auto. The flash will still expose at the correct aperture for the subject and the longer exposure will expose the buildings correctly.

This is a typical shot that has benefited from fill-in flash. The original was lit by direct but harsh sunlight, causing harsh shadows. The flash adds detail to the shadows, for a more acceptable result. As always, the final result may be better or worse, depending on your own tastes. Trying several variations with and without flash is a good way to hedge your bets.

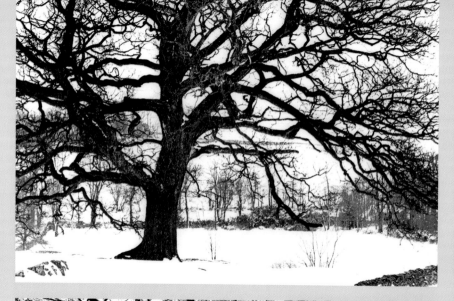

Top The beauty of bare trees in snow is hard to beat, the white blanket helping to remove any distractions by covering them up. Here a 150mm telephoto was used to crop the tree tightly, and a blue color effect was added later on in Photoshop to emphasize the cold conditions.

Center I was attracted by the stark beauty of the tree trunks. The snow has created a graphic quality, as it covers all the fine branches and places emphasis on the dark trunks. I used a wide angle lens to get as many trees into the shot as possible. Remember that you often need to expose 1 to 2 stops more in snow, as the camera meter is fooled into underexposing.

Bottom At Gummers How in the Lake District, Cumbria, I was drawn to the snow covering only half of the trees creating contrast and graphic impact. I used a wide-angle lens that caused converging verticals, so I used the Crop tool to correct them.

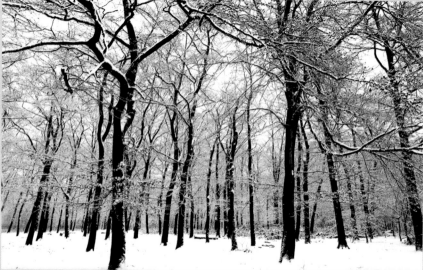

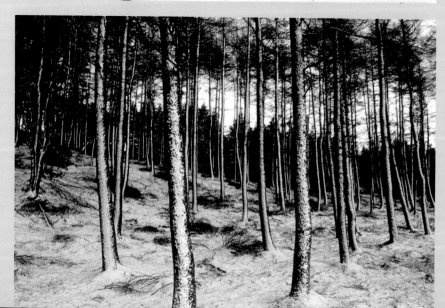

TIP

One of the main problems with shooting in cold conditions is that battery power is used up more quickly. Most modern cameras now use lithium-ion batteries, which are very good in cold weather, but it's still worth while taking some spare batteries. Independent battery producers now make good quality alternatives that are cheaper than name camera brands, and I have seen no difference in quality when using them.

Snow and frost

Snow is a great leveler of landscapes, turning uninteresting locations into scenes of great beauty. Although a vivid blue sky can be very pretty and create picture postcard images, shooting on dark, dull days can be even more rewarding. This is just as well, as snow is often accompanied by gray skies! Try to minimize the area of open sky in your composition, as it will detract from the main subject.

Instead of diluting your image with a mass of dull sky, crop in tightly around the main subject, or have the whole sky area covered with it. If you are using a zoom, try shooting at different focal lengths and review the shots later.

Isolating a small detail and using lots of grain can produce impressionistic images worthy of hanging on any wall. This is a similar technique to shooting on very fast film except you now have the ability to control the amount of grain, contrast, and color saturation. In fact, you can do so either in camera with the ISO setting, or later on in Photoshop.

One final tip: keep an eye out for frozen patterns created by snow or ice. These can be quite beautiful.

Top right This was shot in my local park. It is often areas close to home that are easily accessed when there is a sudden snowfall, so don't dismiss them: they can often be transformed to create exciting new ways of photographing the old and familiar. A fast ISO 800 setting created the grainy effect and enabled me to wander around, hand-holding the camera.

Right This Bill Brandt-style image was given extra contrast in Photoshop as well as being colored blue. The sky was also selected and darkened to add extra mood. The soft swirling storm clouds contrast well to the gritty wall and textured grass.

Above These swans were photographed in foggy, low-light conditions, using a fast ISO 800 setting to get a faster shutter speed and deliberately create a grainy effect. This was enhanced in Photoshop to create a soft impressionistic style. A 150mm lens was used.

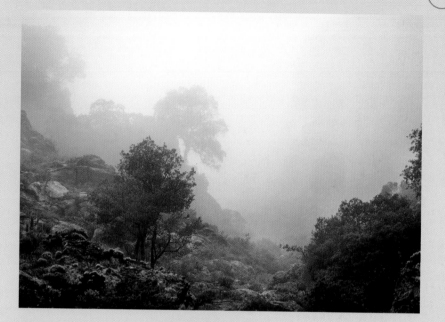

Above Shot by the seaside, a sea fog suddenly appeared and new images suddenly appeared before my very eyes. Ordinary scenes took on a new meaning – one of the great strengths of inclement weather.

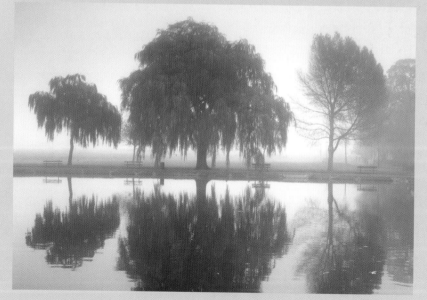

Top One of the most interesting effects about fog and mist is the way it creates layers of depth. Foregrounds can be very prominent and sharp yet backgrounds become pale and transparent. Trees and forests work particularly well.

Above This was a typical British autumnal day where the fog lingered all day long. The reflection was near perfect as there was no wind to cause ripples on the water. The fog has created a soft atmosphere and reduces background clutter to a soft mush.

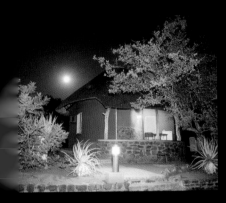

underexposed

overexposed

Above left and right Here you can see the difference between shooting during the day and trying out the flash technique at night. The full moon was an added bonus. I used two flashguns firing manually together during a 45-second exposure.

Above and Right
The only difference between these two shots is the shutter speed. The faster the shutter speed, the less ambient light records compared to the flash, which remains constant. The result is the foreground lit by flash remains the same, while the background lit by ambient has underexposed due to the faster shutter speed.

TIP
Wide-angle lenses also pose problems for flash. Firstly, some are so physically large that the built-in flash unit actually gets cut off, causing vignetting and uneven flash distribution in the bottom center of the image. Secondly, small flash units will have a marked fall off in light at all four corners causing vignetting—especially lenses that are 24mm and wider. The best solution is to use a separate portable flashgun and fit a diffuser, which will soften and widen the light output.

normal exposure

Above These three shots show the difference of bracketing the ambient light source, and clearly demonstrate the different feelings you can achieve by simply altering the daylight to flash ratio. The exposure compensation used was -1, 0, and +1. You can set the camera up to do this automatically via the bracketing menu or manually by using the exposure compensation button on the side of the camera.

Painting with light: landscapes and buildings

Painting with light is a great way to get creative with your photography. You can create some amazing effects by combining a flash gun or torch with ambient light. The only thing you need to consider is the subject: it is best to choose one that isn't too large unless you have some very powerful portable flash units. With the right size of subject, great results can be achieved with just a small flash gun or two.

Below This fountain in Spain needed lifting to give it some impact and detail.

Subjects to shoot

You can attempt to light an object where the only light source is the flash gun (or torch), but better results are usually obtained when you combine many flashes with an existing ambient light source. This might be natural daylight, artificial street lighting, or a combination of both, but you should use it as a base onto which you add more light. You must then run about the subject and flash it from several different angles to build up the exposure. This is why it is often described as painting with light.

Above I used an exposure of 90 seconds at f8 and lit the scene with about 15 flashes using a Metz 45 flashgun. It is important to have fresh batteries for fast recycling, or the charge time between shots will become too excessive. It is possible to hold a black card in front of the lens while the flash recharges if needed. The extra flash has lifted the shot, but you wouldn't know it was lit by flash by looking. The job is done, but in a cool, unobtrusive way.

Correct aperture

As you are using a flash at full power, the only way to alter exposure is by the number of flashes and the aperture. Do some test runs to determine the best aperture and the optimum number, using the LCD display on your camera to check if the first series of exposures is looking good, then making any changes accordingly.

The correct aperture is critical. If you choose an aperture that is too small, like f11 or f16, the power of the flash will be significantly diminished and underexposure will result. This is especially so when you take the inverse square law into account, which states that you must quadruple the light output for every doubling of the distance. In real terms, this means that you must flash the background more than the foreground, as flash will have less effect when farther away. Using a wider aperture, like f5.6 or f8, will help the flash to register more easily in the background.

With the smaller CCD/CMOS sensors in most digital cameras you can get away with wider apertures when lighting large areas. Depth of field increases as the sensor area being exposed gets smaller. This is why large format cameras have such a shallow depth of field in comparison to a 35mm camera at a given aperture and focal length.

Small still life shots

Shooting small still life set-ups at home will not be affected by this problem and you may find a smaller aperture is better if you are using a powerful torch or flashgun. Try a small Maglite torch or manually turn the power down on your flash gun. You can determine exposure by taking a meter reading from the area lit by a torch. Again you are adjusting the exposure using the aperture, so that every time the torch lights part of the subject in a darkened room it is correctly exposed. A few test shots will quickly determine if you are way off the mark, or use a flash meter to help you work your settings out.

Shutter speed and ISO

Ideally, the camera needs to be locked open, using the "B" setting on your shutter speed dial, but you may get away with a very long exposure like 30 seconds if shooting a small object. A manual or electronic cable release is essential, as you will be busy running about firing your flash. With the shutter open you should experiment with the correct exposure. Aim to leave the shutter open, for one to three minutes so that it gives you enough time to flash the subject from several angles. This means your subject cannot be brightly lit by another light source or the shot will overexpose. Try to find a subject that is dimly lit by a light source far away or none at all. An ISO of 200 is a good starting point. Try not to use a fast ISO like 400 or 800 unless you want to create a deliberately grainy effect.

Above top This is the shot before any additional flash was used. You will notice that there is still some ambient light being recorded. This is the base exposure onto which you should add further flashes.

Above Fifteen minutes later, the sky has darkened and about 20 additional flashes from one hand-held flashgun were added. I ran about the scene and hid behind the gravestones so I wasn't illuminated by the firing flash. It is best to wear dark clothing to minimize any possibility of ghosting as you run about. The lens used was a 28mm set to f5.6 for 2 minutes. A cable release was locked open, using the manual "B" setting on the shutter speed dial.

Painting with light: landscapes and buildings

Above Here I used seven flash bursts at different angles to light the interior of this wine cellar in South Africa as uniformly as I could.

Using the flash gun

You will need plenty of flash bursts to successfully illuminate the subject evenly. I would recommend between 10 and 20 bursts at full power for an average shot. It depends on whether you are lighting just the foreground or the background as well. The background will need two to three times as many flashes as the foreground. If you have two or more flash guns that you can use, your job will be made much easier and quicker. As you are using the flash on full power, try picking up a cheap, second-hand, manual-only flash gun just for this technique.

Make sure you don't register in the photo yourself. Hide behind a rock or wall when firing the flash or your silhouette will be seen.

Using a torch or car headlights

It is also possible to create this effect with a torch or even your car headlights. A powerful 1,000,000 candle torch is a must unless your subject is very small. You can paint the scene more precisely with a torch, but the power output and angle of coverage are less than a flash, so a longer exposure becomes a necessity.

The color temperature of a torch or headlights is about 3,200K, as it is a tungsten light source. This means the shot will have a warm bias to it, so you can either shoot using the Incandescent White Balance setting or leave the color alone if you think a warm glow works for the shot. One other remedy is to use a blue 80A or 80B filter gel over the light source (these are available from most good photo stores). The only downside is it will reduce the power of the light source by $1^1/2$ stops.

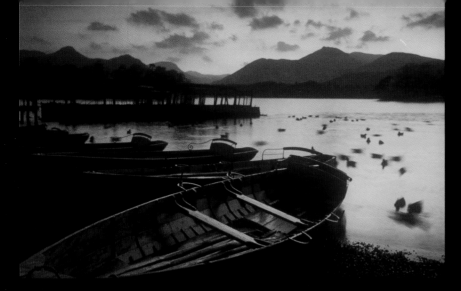

Top This pretty lakeland scene was shot in Keswick, Cumbria, UK and shows the image before applying the car headlights. It is a perfectly nice shot in its own right. The exposure was 8 seconds at f8½.

Center This shot shows the effect of adding my car headlights. I was able to drive my car up to the boats along the slip road used to load boats in or out of the water. I placed the lights on maximum beam and positioned the car—the main limitation is the height of your headlights. The exposure was the same at eight seconds, but the lights have added an interesting fill-in light and some extra impact to the shot. Remember not to let your car battery run down!

Bottom This was the final shot of the session. The shadows have deepened, creating a higher-contrast shot than the earlier version.

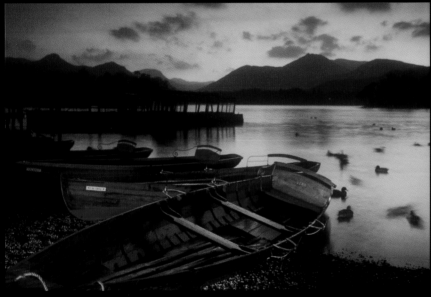

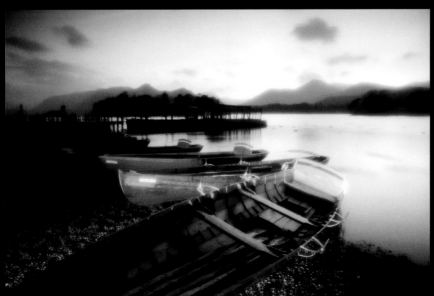

TIP

Whichever method you use, you will need a plentiful supply of batteries to last the night. I use a Metz flash gun that has rechargeable battery packs and I normally take 3 or 4 fully charged packs in my camera bag. Standard alkaline batteries are fine, but rechargeables make the technique a little more economical.

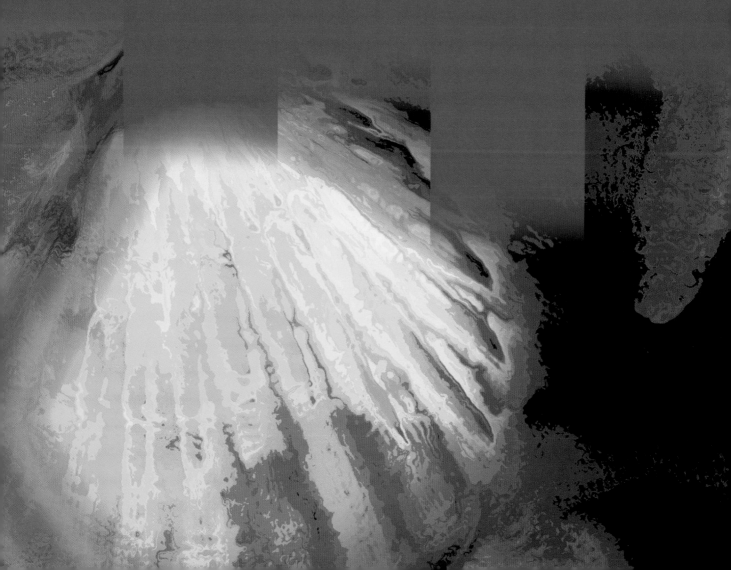

Indoor Low-Light
Photography

Portraits in **natural light**

Daylight is the most common lighting source for informal portraits, and is without doubt the most natural and pleasing way to photograph a person. Inside, the type of daylight you have to work with will depend on the number of windows letting light into the room, and the weather conditions outside. This may vary from bright contrasty sunshine to the more subtle, diffused light typical of an overcast day. You can always hang sheets over a window to diffuse bright sunny light, or use a reflector to bounce light back into the subject so the shadows are less harsh. If conditions are too dark, reflectors and mirrors can help bring more light into the room. Experiment with your options to create a series of different lighting effects. Obviously, the darker it gets outside, the more difficult it becomes to shoot, but you can always increase the ISO setting to give a more impressionistic effect.

For most situations, bright yet diffused light is the most flattering for portraiture. It enables you to maintain a fast shutter speed so camera shake is avoided, and the quality of diffused light is also perfect for maintaining nice skin tones, with no bleached-out, overexposed areas nor any harsh dark shadows. This makes the exposure easier to judge.

Choosing the right background

Great care should be taken to avoid unsightly backgrounds that distract the viewer's attention away from the main subject. A lamp sticking out of their head would be an obvious problem, but look out for irregular textures or strong shapes that will

Right A simple plain black background sets off this subtly lit natural form perfectly.

distract even if out of focus. For environmental studies of people in their workplace, an authentic background that relates to what they do will often improve a shot. For general portraits, a soft bland background is often perfect. If in doubt, get in close and crop out as much background as possible.

Which lens to use

For an environmental portrait, you may want to use a wide-angle lens to make it clear what the person does for a living. Use a small aperture to create adequate depth of field. For most portraiture, a short to medium telephoto from 70mm to 150mm is ideal. A lens with a fast aperture will enable you to shoot at lower light levels, keep the shutter speed faster, and will also throw the background out of focus more (the depth of field will be shallower).

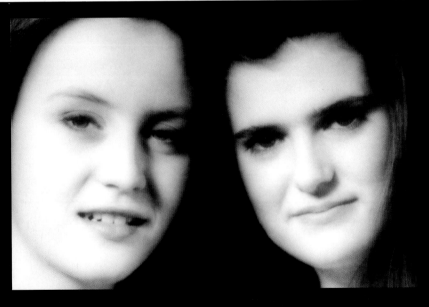

Above These two girls were also shot using window light. A white reflector was used to push some gentle light back into the faces. The image contrast was boosted and the shadow areas were burned in, using the Dodge tool in a similar manner to traditional darkroom printing. This helped to create a moodier more dramatic feeling to the shot.

Tip

Don't be afraid to experiment with different lighting situations. The more varied your efforts, the more you will learn about how to deal with light and tame it once and for all!

Above top Not all subjects have to be humans! Photographing your beloved pet can be rewarding and they are often quite a technically difficult subject to capture successfully. Patience and determination are the keys to success. You know what they say about working with animals and children! A brief burst of TTL flash added enough light to stop the subject falling into deep shadow, and the high speed flash burst froze the cat mid-stride.

Above This wedding day shot makes use of a lucky happenstance, the light through the nearby window highlighting the marriage register. You can either rely on the sun being in the right place at the right time, or arrange the furniture to suit.

Using **flash** indoors

There are many instances when a dash of flash will save the photographer's day. You can use it to boost the ambient light at parties and weddings, or—with slow sync flash—use it more creatively as well.

With fill-in flash, the final result should usually look as natural as possible, unless you are deliberately trying to create a very graphic stage-lighting effect. It can be used on even the brightest days. For example, when a subject is strongly backlit by a window, flash can help you balance the exposure and avoid getting a dark image of the face.

Fill-in flash can be provided by something as simple as a built-in flash unit on your camera, or by a more sophisticated set-up using many large monobloc flash heads. The size or complexity of your system isn't important, as long as it provides enough light for the scene. A large room may need several large flash heads while a simple portrait may use only one flash.

Remember: fill-in flash is the art of adding only a small amount of flash to the main exposure, and this is very different to studio flash, where the flash is the main light source. For this reason, if you're using a dedicated flash unit, try setting the flash exposure compensation dial on the camera to -1 or -2 for a 1:2 or 1:4 daylight to flash ratio. This can be done only with fully dedicated flash units.

Bounced flash

Fill-in flash for portraits is one area where using a flash gun has huge benefits over a built-in unit. Used straight-on, flash has a tendency to exaggerate contrast, which doesn't flatter skin tones at all. With a flash gun, you can rotate the head to point upward, toward the ceiling or to the side, toward a wall. You can see the effects here:

Left Here the head of the flash gun was rotated to point upward toward the ceiling. The lower contrast gives the skin a softer texture and reduces any blemishes and wrinkles. It also reveals more detail in the hair, and eliminates the harsh shadow on the wall.

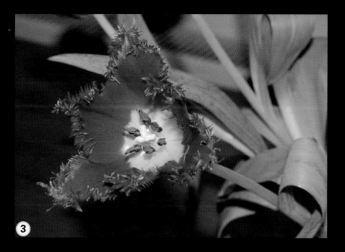

1 These shots show the way shutter speed alters the flash to daylight ratio. The less daylight is used (using a fast shutter speed), the more pronounced the flash effect will be. The first shot shows the image taken without flash. It was shot at f11 at $1/3$ second.

2 The second shot shows the same shutter speed and aperture but with TTL flash added. The tulip now has more illumination and the TTL flash has given exactly the right amount of flash. In this case, the daylight to flash ratio is about 1:1 (ie. both have equal amount). Dial in -2 stops using the flash compensation button to reduce the flash ratio to 1:4 for more natural results.

3 This shot shows what happens when you underexpose the shot. The flash has still given the tulip the correct amount of flash, but the daylight has been significantly reduced by about $2^1/2$ stops. The result is a picture with a dark background. This low-key technique can be used to effect to create graphic stark images with the right subject where the background is deliberately underexposed to throw more attention on the subject. Shot at f11 at $1/30$ sec.

4 Here the tulip has been given a longer exposure so the flash has hardly registered and it has produced a light, overexposed, high-key effect. The exposure was f11 at one second.

Right Shot in Florida, this Native American was dancing indoors in a dimly lit room—not the best combination for photography. I used the situation to my advantage to try out some slow sync flash. As always, it takes practice and judgment to get the shutter speed right, but here $1/30$th of a second produced a good result.

Below This was shot in a butterfly enclosure in a shady dark corner. The natural daylight exposure at $1/2$ second was too long to keep the butterfly sharp. Using Flash freezes the butterfly, but loses the detail in the underexposed background. Shot at $1/30$ at f8$1/2$.

1 This church in Florida, USA was captured during the Christmas festivities. It illustrates the relationship between ambient and flash lighting. The first shot I took was without flash, so it only captured the ambient daylight, producing an interesting and moody image but with no detail of the church in the foreground. The exposure was 4 seconds at f8 on auto.

2 For the second shot, I attached a flash gun to the hotshoe of the camera and used the auto setting. The camera has defaults to its flash shutter speed, $1/125$ second. The fast shutter speed has not let any ambient light register, so all you see is the flash lighting the picture, producing a harsh, contrasty shot with no atmosphere. The exposure was $1/125$ at f8 on auto.

3 Here the mix between ambient daylight and flash produces a more balanced shot, with plenty of detail in the foreground. The camera was changed from auto to manual and the four second shutter speed dialed in at f8. This was the shot I wanted.

Portraits in **artificial light**

Natural daylight is easily the best light in which to shoot portraits, but there will be times like parties and celebrations where daylight is in short supply and artificial light is all you have to work with. If so, the main problem will be the color cast that inevitably occurs. In general, skin tones look better with a neutral cast or with a slight warmth that evokes the natural color of the setting sun. Tungsten lighting creates an orange cast, which can be overbearing. Fluorescent lighting, meanwhile, creates an awful green color that makes people look positively sick!

There are several ways you can improve on this. Try altering the white balance setting on your camera, add some more daylight balanced light from a flash gun, or use filters in front of the lens or over the light source to correct it.

Tip
Another way to remove a problem color cast is either to remove the color entirely, or reduce its intensity. You can easily turn the image to Grayscale (see Page 146) or use the Hue/Saturation slider (see page 141) to reduce the saturation to a more suitable level. We also tackle removing color casts in software on page 140.

Above Two 800W tungsten lights were used on either side of this model to create soft, even lighting without any harsh shadows. The orange color cast was reduced but not entirely removed in Photoshop to create a nice warm glow.

Right This intimate shot was created with general room lighting and two 800W tungsten lights. One was placed closer to the subjects to add a glow effect, and these were filtered with 1/2cc blue gels to reduce but not remove the color cast. A soft focus filter and an ISO 400 setting create a soft grainy feeling that enhances the romantic quality of the shot.

Above This was shot in DisneyWorld, Florida. The strange fluorescent lighting created an otherworldly effect full of impact. This is one case where color cast became the star of the show!

Right This young girl was photographed with two 800W tungsten lights that were filtered blue to correct the orange cast of tungsten lighting. A simple black background was used to avoid clutter in the shot.

Far Right A charming and friendly couple, shot in a typical British pub. Their friendly demeanor has resulted in a shot full of life and fun, which makes it easy to live with the strong orange tungsten lighting color cast in this shot.

Silhouettes

Using silhouettes is a fun way to create striking bold shapes in your images. They can be made from any object, but work best when the object is easily identifiable.

In technical terms, silhouettes are created when the subject is underexposed by several stops from the main exposure. In order to do this, the main exposure needs to be created by a bright source of light. The subject should then be placed between the light and camera to create the effect. Essentially you are taking a light meter reading so that the main light source is correctly exposed, which by default underexposes the subject in the foreground.

On location, you can use the sun to create this effect, but in the studio you need a single bright light source. The subject then needs to be backlit to create a high contrast situation and the correct exposure given.

The advantage of the studio is that it becomes much easier to position your objects. Outside, your shape is defined by its position with the sun behind it, and if you can't move the object you may have to wait for the sun to move to the ideal position, where it provides the necessary backlighting without any flare coming in to ruin the shot. In the studio, you can play around with the light source until it is perfectly positioned.

The correct exposure

In bright, light the camera meter is often fooled into underexposing the image, which is perfect for silhouettes. To get a silhouette, you simply leave the camera's meter setting alone. If the light source is diffused by paper or opaque plastic, you get an evenly lit background that is easy to meter from.

Right Small colored gels made by Cokin were placed on top of a lightbox, with some nuts and bolts randomly scattered on top to produce this colorful and effective image. The center-weighted exposure automatically created a silhouette.

Left A sheet of ordinary waxed cooking paper was used for the background to give a nice textured effect, with two lamps placed behind it for even illumination. The bottle and glass were placed in front and the shot was exposed at the camera meter setting to create the silhouette.

Below left The fire itself was the actual light source and its bright flames made the logs in the foreground go dark to create a nice moody shot.

Below right I used an old slide copier to photograph the leaf. The real leaf was placed in the slide holder inside a 35mm slide mount. The cameras auto exposure did not work, but tests were done using the LCD screen and I bracketed around the best exposure. The slide copier produces excellent images, although depth of field is fairly shallow at about F8. I used a bright tungsten light source to backlight the leaf.

Photographing **interiors**

Interiors offer the photographer a challenging and difficult subject to shoot. You can be faced with mixed lighting, which is always difficult to balance correctly, and the exposure can often be hard to judge. This won't change whether in a dark old church or a brightly lit modern office interior.

Using flash to balance the light

The main technique most photographers use to balance interiors is to pump in extra light using flash or tungsten lights. Most interiors are dark (even brightly lit ones) when compared to the daylight flooding in through the windows from outside. One technique is to wait until the outside light is darker later in the day, but this means the interior will look like a night shot. This works well in many cases, but if you want a naturally lit daylight interior you need to use extra lighting to boost any ambient light already present.

It is best to bounce the light off a wall or ceiling so it produces a more diffused natural light source that doesn't cause any harsh shadows. If the room is big enough, you could use a large soft box attachment over the flash head. Usually the aim is to create a balanced natural look, so that the viewer is never aware that any additional lighting has been used.

Color casts

Shooting at night will often result in difficult color casts, and when these are difficult to remove completely, you may just have to live with them. If all the lighting is the same, use the appropriate white balance setting (usually Incandescent or Fluorescent) to cancel the effect. Use the Preset for the most accurate way to neutralize a color cast (see page 40). If using the Incandescent setting and you want to add flash, try putting an orange filter over the flash gun to keep all the light sources the same color. Experienced interior photographers will try several different methods—with and without flash, flash filtered, and with different white balance settings—then see which turns in the best result.

Here the colors were left as they were, resulting in a bright, colorful image that matches the modern style perfectly.

> **TIP**
>
> In Photoshop you can use a selection tool to select areas that can be individually corrected for color. This can be long-winded, but the final effect is often worth the effort. You can also use the Sponge tool set to Desaturate to reduce any color casts: this is especially good on white surfaces that have gone orange.

WIDE-ANGLE LENSES AND INTERIORS

One difficulty with interiors is that you need wide-angle lenses to do them justice. Many digital cameras fall way short of supplying a wide-angle lens, and only digital SLRs will enable you to fit a lens with a low enough focal length to work. You will need at least a 24mm lens for most interiors, and something wider for smaller rooms. With an average sensor having a 1.5x focal factor, an 18mm lens would become a 25mm lens. To get a true wide-angle equivalent of 18mm with this focal factor, you would need to fit a 12mm lens. The excellent Sigma 12-24mm f4.5 to 5.6 does a great job, but most lens manufacturers now offer a good range of super-wide lenses.

The warm colors of the wood and bricks were enhanced by the warm colored tungsten lighting. The flash was left unfiltered, which reduces the tungsten effect to give a 50/50 mix of natural and artificial light for a warm color cast that is not too overpowering.

Here the interior and exterior would have been difficult to balance on film without filtering every single light source. Selecting and treating specific areas in Photoshop enabled me to reduce the effects of orange tungsten lighting where necessary.

This stylish apartment was shot at night, using one main 500W flash unit bounced off the wall behind the camera. The left side had more daylight from a window, so is slightly cooler in color to the main interior, where the tungsten ratio was higher than the daylight. This has resulted in a beautiful mix of different and exciting colors.

Candlelight

Candlelight is one of the oldest forms of illumination known to man and was used for centuries before the light bulb was invented. Candles are used in religious ceremonies, birthdays, funerals, and romantic candlelit dinners, so they have many varied associations.

The warmth of candlelight measures about 2000 on the Kelvin color temperature scale, which is even warmer than tungsten lighting. It is a small-point light source that emits a bright light at close quarters, but its luminance soon falls off to yield powerful and dramatic images full of mood and shadows. You could use several candles to make the image brighter, but the glow from one candle is often enough to produce a beautiful atmosphere.

Use a low ISO setting to retain detail in the picture, but try experimenting with higher ISO settings to inject some extra grain, which will yield a more atmospheric and painterly feel to your shots. This can be done later on in Photoshop (or another image editor) if necessary, or in situ if you are struggling to get a suitably fast shutter speed to freeze the subject.

The warm orange color cast from candles is nearly always welcome—it just evokes all the right emotions—but if you want to reduce the effect this can be done easily in Photoshop later on (see page 140).

Try using candles so they go out of focus, or try concentrating on a small detail to make the candles look bigger. Using a dark background will enhance the glow effect from a candle, as will a soft focus filter.

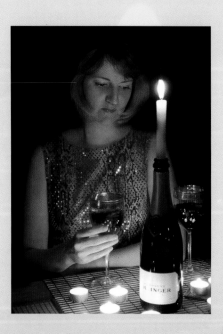

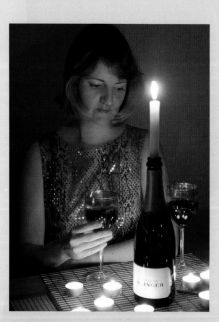

This portrait has a nice reflective mood (and the subject sat very still during the exposure). Only candlelight was used and the color was tweaked later on using the Photoshop Raw plug-in. The red wine was actually cranberry juice, which produced a nicer red than the real thing, which went almost black. I took this one for some Photoshop work later. The background was selected and darkened using Levels. It was feathered by 45 pixels for a very soft edge. The selection was kept fairly rough so the edges of the subject also darkened slightly, thus avoiding a cardboard cutout look.

Below and Bottom These candles were shot at a wide aperture of f4 and then again at f22. The difference in the depth of field is apparent. Which one you prefer is down to personal taste, as both are valid interpretations.

Below and Right By varying the angle of view and moving in close with a macro 90mm lens, the candles become semi-abstract and the flames become dominant. Be careful how you arrange out-of-focus flames in the foreground.

Below center A sheet of ice frozen overnight in the freezer was placed in front of the candle to produce an interesting study in light and texture.

Below This beautiful low key study was shot with one candle placed behind the glass so it was backlit for effect. I have a one million candle power torch, but the effect of one candle power is far more beautiful. As always, simplicity is the key to many successful shots.

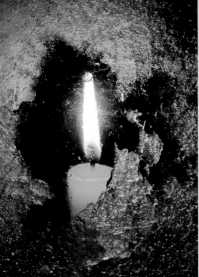

Christmas and Halloween

Festivals always provide the photographer with opportunities, and Christmas and Halloween are a boon for atmospheric shots in low-light conditions. At Christmas, many streets are decked out in decorations and lights that are crying out to be photographed. At Halloween, there will be Jack O'Lanterns, spooky decorations, and trick-or-treating kids to make the most of.

The best time to photograph outdoor scenes is at twilight after the sun has gone down, but before all the color has left the sky. Although larger towns offer the most spectacular decorations, don't forget small villages can offer interesting subjects to shoot. Keep an eye out for the smaller details that can sum up the atmosphere. Use a tripod for maximum stability and take a couple of zooms, a wide-angle lens, and a telephoto lens to maximize your shooting options.

Indoors, don't forget to record the inside of your house and the people coming to celebrate with you. Use TTL flash to remove any color casts and use a separate flashgun to increase power for larger interior spaces. Take shots of people as they put up the decorations or apply make-up if putting on fancy dress costumes.

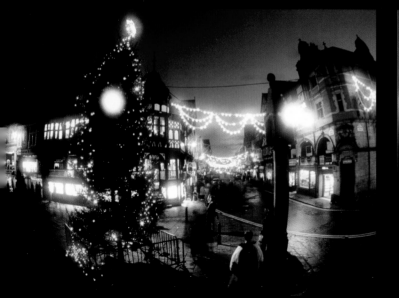

Above Taken from a firmly-positioned tripod, this shot adds interest to a quaint Christmas-scene in a small English town by using a fish eye lens. The late-evening light gives the sky its rich blue glow; together with a long exposure (luckily the people nearest the camera moved relatively little)

Above It never hurts to look for a new angle on things, and reflective surfaces abound at Christmas. Here a Christmas decoration is captured via a neighboring bauble. The short depth of field makes the distant decorations look even more exciting to the eye, too.

Halloween

This traditional festival takes place in late October across the USA and some European countries as well. In Mexico, it is called the "Dia de los Muertos" and people dress up in skeletons and hang about cemeteries chatting to the local residents! It is a great time to capture the spirit of children as they have lots of fun.

Look out for groups of kids trick-or-treating and use fill-in flash to keep the detail in their costumes when shooting at night. If the flash is ruining the atmosphere, try turning it off and using a higher ISO setting, or try shooting with candles or a torch or single bright porch light. Take detail shots of faces, costumes, and Jack o'lantern pumpkins when lit up by candles. Try to create a ghostly image with a long shutter speed and someone running about in a white sheet. Keep your images simple and don't try to cram too many different elements into one shot.

Above left Shoot to expose for the candlelight inside, and the pumpkin will automatically go dark, creating an evil face effect. Add a little bounced flash to add some detail to the exterior skin or try the "painting with light" technique discussed on page 98.

Above By increasing the exposure, you can alter the effect of the pumpkin. More exposure brightens the inside and the glow starts to shine through the pumpkin, depending on its thickness.

Pumpkins

It is great fun making jack o'lanterns and even more fun photographing them. The larger the pumpkin, the more candles should be used to keep the interior bright. Try placing the pumpkin against an interesting background to create a proper still life shot and think about the shot you want before shooting it.

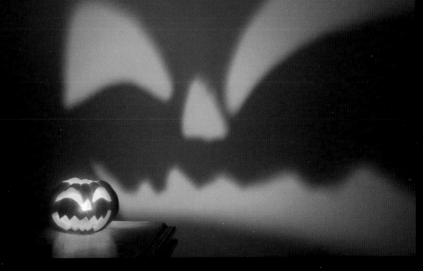

I experimented with using the light from the pumpkin, and a flashlight, to create a ghoulish face. I had to be careful I didn't singe my chin! I then montaged the face and pumpkin together.

Here the pumpkin was placed looking toward the wall to create the eerie shadow. I then turned the pumpkin around to shoot the face and montaged it into the shot later on. A simple but effective idea.

Concerts, plays, shows, and parties

There are many times when you might want to record a show, concert, or play, especially if it involves friends or family members. This means adopting a similar technique to photographing interiors or indoor portraits. The light levels will often be low, especially in plays where the lights may be turned down to create a certain mood, and if they haven't been turned down, then they will almost definitely be brightly colored to the point of oversaturation. Trying to correct these colors is almost impossible, but in most cases it doesn't really matter, as the Technicolor look is all part of the desired effect.

Note that professional plays or concerts may ban photography outright, so concentrate on smaller shows and amateur dramatic societies if you want to practice your technique. Smaller groups will be happy to have someone take decent photos during rehearsals.

When shooting events at home, using flash is easy, but at most concerts and indoor events you risk being turfed out, as it may ruin the show for other people. I was doing a commissioned shoot of a circus where permission was granted to use flash, but after five or six bursts, complaints from the audience forced me to turn it off!

Interior action photography is a lot easier with a fast, wide-aperture lens. I use a 28mm f1.8 or a 50mm f1.2 for most shots, as I can use it without flash, and so avoid distracting people and losing the natural candid feel to the shot.

This scene is typical of a theatre event indoors. Dark settings with moody light will push your techniques to the limit. Use the fastest aperture you can and increase the ISO until you get a suitably fast shutter speed.

Left This was a laser light show. It kept changing rapidly, so I just shot off several frames and waited to see if I caught anything interesting. Several frames were successful.

Below Here the singers were enticing people on stage, and I couldn't resist taking a shot! TTL fill-in flash ensured the people were frozen mid-action, although some blur has occurred.

Left The beautiful ballroom at Blackpool Tower, England, shot during a quiet week. A wide-angle lens was used to capture the full grandeur, with a tripod enabling me to maintain maximum sharpness during the long 10-second exposure.

Sports

t's a tough life being a professional sports photographer. As well as the light and elements causing you problems, you often have to travel huge distances to get from one sports arena to another, so as well as being cold and hungry you are often tired as well.

This is a typical winter afternoon in Britain; cold, wet, windy, and low light. By shooting at a local rugby match, I was able to get in close. I used a 300mm lens at F5.6 with an ISO of 800 to freeze the action. The colors were almost non-existent anyway, so I converted the image to Grayscale and boosted contrast.

As an amateur, you may find it difficult (or impossible) to gain access to popular events, but local events, particularly amateur ones, should be easy enough. In fact, you may be encouraged to take shots for the local team, and this makes a great way to practice and build on your technique. Also, some larger teams may offer you access to youth team or second team training sessions, where you can shoot up-and-coming players at work.

The perfect sports camera

Modern professional cameras help enormously in the fight to get sharp, well exposed action shots. The ideal is something with a large buffer between the processor and the memory card, so you can take many shots before this temporary cache provides enough. A fast shutter speed should get you 8 frames per second or more, and the auto focus will be tuned to get pin-sharp clarity in a fraction of a second. The white balance settings will be able to handle floodlit stadiums, and the camera will be built to withstand the rigors of life on the move, with the important weather sealing to stop rain getting inside the camera.

Pros will use very fast telephoto lenses like a 300mm or 400mm f2.8 lens. These are extremely expensive—and may cost more than the camera itself—but enable you to use fast shutter speeds because of the large apertures. As you may not have such a large aperture to work with, compensate by using a faster ISO. Fast lenses really come into their own when the light levels are low and you are already using ISO 800 (which is quite common at night sports events), but if you have reached the limit of lens aperture, ISO, and shutter speed, why not try deliberately blurring the subject?

Remember to capture the sporting event with different lenses. Use a wide angle to capture the entire stadium under floodlights and telephotos to get in close to the action.

Freezing the action

Freezing the action is everything, as it enables the viewer to see exactly what's going on in a shot. A good sports photographer will be able to anticipate the next move by having expert knowledge of the sport and its terrain. Set yourself up in a good position to view the action as it passes by. This may be side on or at a more acute angle, depending on the shot you want. Pre-planning is essential to get successful results, and you need a fast shutter speed like 1/1000th sec to freeze the action.

Blurring the action

Although most action shots will be taken at fast shutter speeds to freeze the action in its tracks, try experimenting with slower shutter speeds to create intentional blur. This adds to the overall atmosphere and excitement of the image and can produce some interesting abstract images. Try using different shutter speeds to find the one most suitable for your chosen subject. A good starting point would be $1/30$ sec.

Panning

Panning is a great technique for action shots, and one you should practice getting perfect before going to an event. It involves you following your subject as it passes by. Auto focus and auto exposure help by removing unnecessary and distracting technical problems, and a high-speed multiple exposure setting is a must. You should focus on your subject as early as possible and keep following it with your eye to the camera. At the optimum moment, take a burst of images. You can use a fast or slow shutter speed, depending on the effect you want. The slower the shutter speed, the more blurred and attractive the background becomes, helping to isolate your subject nicely. Use a burst of fill-in flash if the subject is close enough to freeze it mid-flow. This will often create a sharp and blurred effect in your subject, at the same time enabling you to capture a sense of movement and detail together. The more you experiment, the more you will understand the interaction between shutter speed and subject.

Zooming during exposure

Another great technique is to zoom in during the exposure. You will need to use a slow enough exposure to enable you to physically zoom from one end of the focal length to the other. This may be tricky during the day, so try putting a polarizer or ND filter over the lens. This will reduce the shutter speed by at least two stops. At night, it's easy. Place the subject in the center of the frame and zoom as you expose. A tripod makes life much easier when using this technique.

1 Shot in Germany, at a Chelsea vs. Besiktas soccer match. The camera was turned from the game to point at the colorful flare in the crowd. A 400mm lens at F2.8 with a shutter speed of 1/500 sec was used with an ISO of 1000.

2 This charming shot was taken when a soccer match was delayed by 1 hour and it was too much for this little lad. A 400mm lens at F2.8 was used with a shutter speed of 1/125 at 1600 ISO. At such a fast aperture depth of field is minimal.

3 English soccer team Liverpool celebrate winning the Charity Shield in Cardiff's Millennium Stadium. A 400mm lens was used at F3.5 with a shutter speed of 1/125 at 400ISO.

4 This shot of tennis star Tim Henman, cheered on by his home crowd at Wimbledon, London. A 75 to 200 lens was deliberately zoomed during the 1/30 sec exposure at ISO 200, keeping him near the center of the frame.

Painting with light:
still life

Painting with light is a beautiful technique in any context, but when combined with still life photography, it yields stunning, artistic shots worthy of framing like a painting. Typical exposures can run into minutes, so a tripod is of paramount importance for this technique, as you are going to be too busy running about using a torch or flash-lighting your subject to hold the camera!

As we noted before (see page 29), "B" or bulb setting is necessary to allow for the long exposures. If your camera's shutter has a built-in cable release thread, you can use a cable release to keep the shutter open for as long as you require. Other cameras (including my own) need an electronic infrared remote to do this. This may not be included with the camera and will cost more money to buy as an accessory.

Don't panic if you have neither! You can shoot using your longest shutter speed, which may be up to 30 seconds, then paint different areas of the subject and build this up using as many exposures as you like. You can then create a montage of the best bits in Photoshop later on. This is slightly more long-winded, but will work very well. To work properly, this technique requires perfect registration from one shot to the next, so don't change the camera angle or lens. Even with a shutter release, this technique can be a little hit and miss—you may find that you will take bits from several different exposures anyway.

This was set up in a studio with a hand-painted cotton background, which I painted myself. The single main tungsten light was set to a medium intensity (also filtered blue to correct the orange color cast) and was used to partially light the sunflowers and background. I then picked out the highlights

with a torch. A low wattage light placed in the room also enabled me to see exactly where to shine the torch. The exposure was two seconds at f11 at an ISO of 100. The main light was then switched off and the torch used on the highlights, at approximately two seconds per flower.

Notice the difference that the torch has made to the highlights of the second shot. They glow more. This would be difficult to recreate with normal large tungsten lighting.

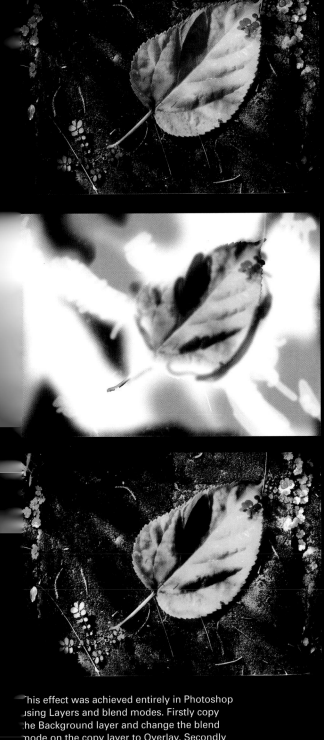

Exposure

As when you use this technique outdoors, the aperture will be determined by trial and error from test exposures—the great thing about digital is that you don't have to guess or wait for your film to come back from the lab; you can fine-tune your settings using the LCD screen. Use the lowest ISO setting on your camera for finest detail and to minimize any noise problems. A low ISO setting between 100 and 200 will also allow for slower shutter speeds, which is essential for this technique to work.

If the subject is several feet away from you, try a starting point of f8. Remember that the correct exposure will be largely determined by aperture, not shutter speed, as the subject will be mostly dark. When your light hits a particular part of the subject, the larger the aperture, the brighter the effect will be. However, if you are working on a close-up of a still life subject, smaller apertures and weaker light sources are required. Using the inverse square law, it should be noted that the light required to correctly illuminate a subject quadruples every time you double the distance between yourself and the subject.

Try pointing a torch at a white sheet of card and take a reading from this using your camera's meter. Remember to increase exposure by two stops to take into account the bright white surface. A hand-held light meter is the most accurate way of assessing flash in small areas, but tests using the LCD display will work in a pinch—use them as you would a Polaroid. Once you have settings for a particular flash gun, write them down. They will be the same if you use the same aperture and distance to subject in the future.

This effect was achieved entirely in Photoshop using Layers and blend modes. Firstly copy the Background layer and change the blend mode on the copy layer to Overlay. Secondly choose the Brush Tool and also change its blend mode to Overlay. In the Set Background Color choose white to lighten the image and black to darken the image. This produces an interesting technique that mimics the effect of a torch.

Painting with light:
still life

1 I used a multiple exposure for this shot, but you could easily shoot two separate images and montage them. A tripod would help to make registration perfect. The black apples were sprayed with a can of black paint, while the red apple had two green leaves attached from the garden! The apples were carefully laid out on black velvet (non-reflective) and sprayed with water for effect. The black apples were lit by a single light covered with a blue gel (the color can be altered in Photoshop later if required) and the red apple was removed.

2 After making my first exposure, I replaced the red apple and turned off the blue light. In total darkness, I carefully used a snooted torch to illuminate the red apple only. This gave the shot its interesting contrasts between warm and cold colors.

Light sources

As with painting with light outdoors, you can use a torch or flash to light your subject. Of course, the light source will also dictate the aperture. Flash is generally more powerful, but for more intimate still life shots a small torch will give you delicate exposure work. Try fitting it with a small black card snoot (cone) to narrow the beam even further for fine detailed work. A flash will illuminate a wider area, and the shorter duration doesn't give you time to see what you're painting. If you have an old slide projector gathering dust, this can also make a good strong directional spot light source—placed low to the ground it makes interesting side lighting effects.

The main secret to success with this technique is to partially light your subject by traditional methods. Use a weak light source or deliberately underexpose the entire shot to give you a base exposure to work from, then keep the torch moving constantly over the parts of the image that you want to add highlight detail to, remembering that the longer you leave the torch in one area, the more it will overexpose. If your exposure reading suggested four seconds at f8, then you know that an exposure greater than four seconds will cause overexposure.

I always work in manual focus mode, as even the best auto-focus systems hunt in the low-light levels required for this technique. Switch to manual, using the button that is usually found on the lens or camera body near the lens release button.

Right The shot had a base exposure and I then lit the tulips with a torch briefly to stop overexposure. Parts of the background were darkened in Photoshop, but the dappled effect was more or less created in camera. I used various twigs and bits and pieces in-between the light source and background to create the dappled effect. Always try to do as much as possible at the taking stage—it stretches your imagination and develops your photographic skills. Beautiful lighting has to start in camera, but can always be tweaked later on.

Right This was set up in a studio. I used a large sheet of plastic and poured the sand on top. I roughly created the ripples and then used a hairdryer to soften the lines for a wind-blown effect. The shells were placed on top and I used a low light from the side and a torch to create the final effect. Color and contrast were boosted later in Photoshop.

Alternative **light sources**

You don't always have to use traditional means to light your subject. Sometimes you can find other light sources that by their very nature create a different feel to your shots.

Lightboxes

You can purchase a professional lightbox from a shop, or make your own. You need a sheet of opaque white sheet acrylic and a suitable light source to shine from below like a large lamp or flashgun. A large lamp is preferable, as you can see the effect of the light source on what you are shooting more easily. Pro lightboxes use special 5,500K daylight balanced tubes, so won't cause a color cast like 3,200K tungsten light would. To get the same effect with Tungsten, filter the light with a blue 80A or B gel or use the Incandescent setting in your camera's White Balance menu.

The lightbox produces a soft, even light and can be used to backlight your subject. Place your subject on top of the lightbox and shoot from above for best results. It is much more effective if you choose objects that are translucent so you get areas of shadow and areas being backlit.

Above This Chinese Lantern fruit (Physalis) was shot using a 90mm macro lens with a wide aperture of f4, so most of the image is deliberately de-focused. Only the lightbox was used to illuminate the fruit. Exposure was around two seconds.

Above Here I used a sheet of glass but completely covered the sheet with the lantern fruit so very few gaps appeared. I placed a sheet of black velvet on the floor to make any small gaps go black and used one anglepoise lamp (from bottom right) to backlight the subject. The sheet of glass was balanced between two chairs. It has produced a dramatic effect.

Above Here I sprinkled sand in between the physalis lantern fruit, placed on top of the lightbox. The light has shone through where there is no sand under the fruit, but I also used a torch from above to add more detail. Without the torch, the sand and fruit would have been much darker. I used an exposure of 20 seconds at f11 with a macro lens.

Slide projector

A slide projector can produce some very exciting images if you use its very harsh point light source to create dramatic side-lighting. The light source is a very powerful halogen light bulb, which gives a slightly cooler color cast than standard tungsten bulbs. You can use a blue filter to correct the cast if required. Because the projector is small it can be positioned quite low.

Small lamp

A small lamp, especially an anglepoise design, can be suprisingly effective for producing small, table-top still life studies. Use it as the main light source, to light the background, or try combining several at once to create a mini studio set-up. There will be a Tungsten color cast, but this can be eliminated using the White Balance settings, or by using Photoshop's color correction facilities later (see page 140).

4 I placed sand on a plastic sheet, created ripples with my finger, then used a hair dryer to give a wind-blown feel. The projector (the only light source) was placed to the top.

3 The second image has a silver sheet of card placed to the bottom, to add extra light to shadows.

2 Fit a slide in the projector to project an image onto your subject. Here a slide of shells was used and a sheet of textured glass was placed in the path of the beam to further break up the light.

1 Here the projector, with a photograph of shells placed in it, was focused sharply onto the starfish.

Left Top The projector was placed at a 45° angle to the top left, where its low angle has created deep shadows (the stones were sprayed black), though I placed it just high enough to light the leaf. The beam was focused on the leaf, and I used a blue filter on the projector's lens to correct the color cast. Shot with a 90mm macro lens at f16 for two seconds, with a small silver reflector to add extra light to the leaf.

Left Center Here I placed a sheet of polarizing film on top of the lightbox and placed the glass beads on this. The camera lens was also fitted with a polarizing filter, and when this was rotated it created the cross-polarized effect—where the two filters are visible they go black. The strange shapes inside the beads are stress fractures. It is a technique used in industry to find stress problems, but has been adapted here to create an intriguing image. The two filters need to be parallel for it to work properly.

Night Photography

Shooting **the moon**

Man has had a fascination with the moon for millennia. It is our closest celestial entity—an object of wonder and mystery to most of us—and it always adds a great deal of atmosphere to a picture.

The moon will vary in size depending on which lens you use, growing in size by approximately 1mm for each 100mm of focal length. A 500mm lens will give a moon that is actually 5mm in size on your CCD. A wide angle lens will only show the moon as a pinprick, but even when small it can add to the mood.

If you own a digital camera with a fixed lens, you will be limited by its maximum focal length, which makes it an advantage to have one with a range going up to 300 to 400mm (35mm equivalent). Of course, with a digital SLR's interchangeable lenses you can go up to 800mm or more. Such a lens will be very expensive, but you can hire them for short periods from specialty pro camera shops at reasonable rates.

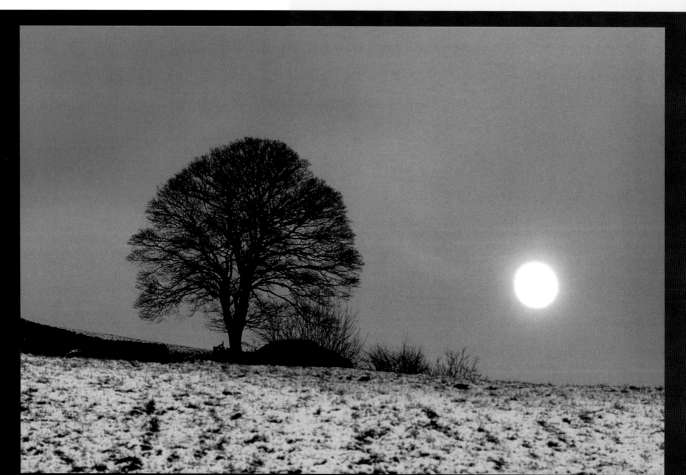

How to shoot the moon

Shooting scenes that include the moon isn't tricky, and it can add to a pleasing composition. Note: the moon will generally overexpose to a white blob unless the overall scene is quite bright, which is unusual for night shots. However, detail in the moon can be captured when it is still rising and there is plenty of ambient daylight around.

Longer exposures also bring another problem. The longer the exposure, the more chance you have of the moon moving in the frame during the exposure, with exposures of 20–30 seconds or more turning the moon into an elongated blur. Don't worry: you can fix this in Photoshop later.

Remember that optical focal length is more important than digital zoom here. It's tempting to use the latter, but you'll end up losing detail in the image.

Opposite This is a straight shot that I saw while driving back from a day out in the Lake District, Cumbria. When you see a shot like this, you have to stop and grab it, as it won't happen again. The lens was a 70–210 at the 210mm end, shot at f8 for two seconds. The moon has obviously burned out, but still has a huge impact to the overall shot.

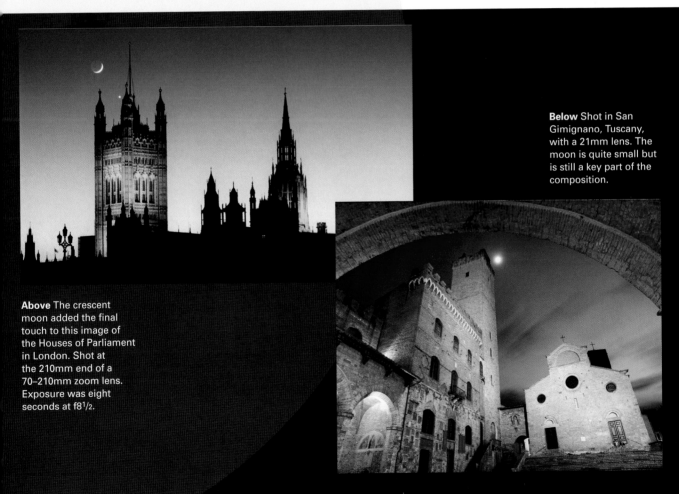

Below Shot in San Gimignano, Tuscany, with a 21mm lens. The moon is quite small but is still a key part of the composition.

Above The crescent moon added the final touch to this image of the Houses of Parliament in London. Shot at the 210mm end of a 70–210mm zoom lens. Exposure was eight seconds at f8$1/2$.

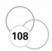
Shooting **the moon**

Exposure and aperture

Your metering system will be fooled into overexposing the moon, as it is a tiny blip in a sea of black sky. The camera will try to make the black areas lighter to conform to a standardized 18% tonal range, so try to spot-meter from the white area of the moon only, or do a series of brackets, underexposing in half stops from the camera's multizone meter setting. Remember that a spot reading from a white object needs two stops more exposure than the actual reading for a correct exposure. If your camera has a zoom facility on the rear LCD, zoom in and check. My EXIF camera data shows that an exposure of $1/250$ at f5.6 with an ISO of 200 yields a correct exposure for a full moon, but yours may differ. You may want to bracket an extra shot $1/2$ stop under this to make sure all the delicate highlights have been captured. Digital cameras are notorious for losing highlight detail, especially with JPEGs, so shoot in the RAW format to retain the highest quality "negative."

You don't have to use a small aperture as the center of the image will still be sharp when shooting wide open. Detail around the edges of the image won't be so important, and you will be able to alter the exposure only by using the shutter speed if shooting at your widest aperture, though clicking down half to one stop shouldn't be a problem.

Below Shot in Spain with a 28mm lens at f8 for 8 seconds at 100 ISO. The moon is quite small but is still a vital part of the composition.

Below right Shot in Fort Lauderdale, Florida, the lens used was a 135mm at f11 for four seconds. The cloud has added a nice textural feeling to the otherwise bland sky and a nice glow has been produced around the rim of the clouds. It was shot while there was still quite a lot of ambient daylight left in the sky, which has helped to keep the exposure shorter.

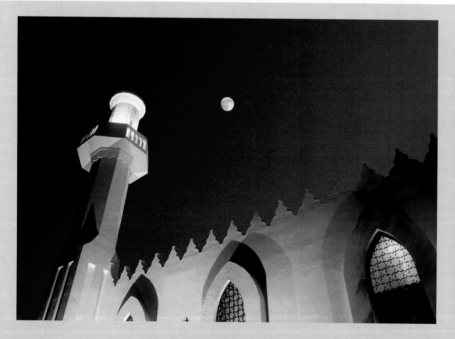

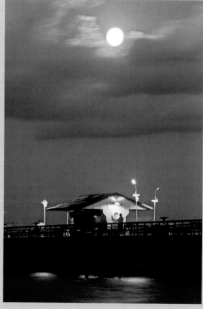

Keep it steady

It is imperative that you use a tripod to keep the camera absolutely still during the exposure. Even the smallest vibration will cause images taken with a long telephoto to lose sharpness, as they are so highly magnified, so use your camera's self-timer, or a cable or electronic release to avoid pressing the button.

If you are still having problems with camera shake, try an alternative method. Choose the "B" setting with a cable release or the longest shutter speed available. Place a matt black card in front of the lens without touching it, and fire the shutter. Wait for several seconds to let the camera become absolutely still, then remove and replace the card as quickly as possible. The speed at which you move the card becomes your shutter speed—the faster the movement, the faster the shutter speeds. You can also alter the aperture to make the image brighter or darker.

ISO

Try to use the lowest ISO available, especially if you want to use the moon in a montage at a bigger size later on. This will reduce noise levels and allow for the greatest detail to be captured. Shooting on a faster ISO may produce so much grain that a small moon becomes unusable.

SHOOTING FOR A MONTAGE

It's worth creating a file of moons shot at different phases during the month, as this will give you a choice ranging from the classic crescent shape through to a full moon. Shooting on a clear, cloudless night is essential unless you are shooting the moon and sky together for a combined effect. Summer months are worst for this, because there is usually more atmospheric pollution. Cities exacerbate this problem and add a new one—light pollution— whereby street lights cause enough flare and unwanted light to make the black sky overexpose and turn red. If this causes a problem, shoot in the country or an area without street lights.

Below left and below Shot with a 50mm and 400mm lens, these two shots show the marked difference of shooting the moon at different focal lengths. At 400mm, it becomes very difficult to add much detail from the background, which can often give a sense of place.

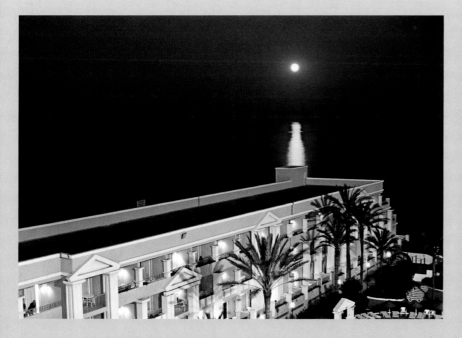

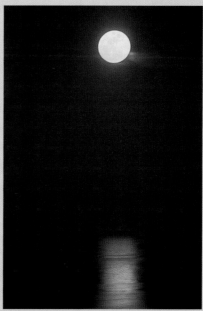

Star trails

Star trails offer a fascinating glimpse of how the Earth is in constant motion. They are technically challenging to photograph and require hours of patience, but any camera with a bulb setting will work. If you have the patience, the rewards can be truly magical.

Star trails are simply stars moving across the night sky as the Earth rotates on its axis. If they are bright enough, they will record as a white streak. The principle is the same as a car's headlights becoming a long streak of white or red light as it quickly passes by during the long exposure. The stars are much less bright and move imperceptibly to the human eye, so the exposure has to be measured in hours not seconds.

You will need a sturdy tripod to stop camera shake ruining the shot. Weigh it down with a bag to give even more stability in windy conditions. The exposure is measured in hours, so don't get too worried about a few minutes. Use a slow ISO for maximum fine grain and detail, as the star trails are very fine lines. A fast grainy ISO will ruin this delicate detail. The aperture is more critical and tests should be done at your chosen ISO. Do a five-minute exposure at each aperture up to F8 to see which aperture gives the nicest result.

You will, of course, need a crystal clear night without any cloud cover whatsoever. If it clouds over during the exposure, the results will usually be disappointing. Winter months are often better, as the cold air is less polluted with heat and pollution making it much clearer. You can also start the exposure much earlier, which will enable you to finish by midnight. Starting at 10.00pm in the summer will mean finishing as you approach dawn. Indeed, you may run out of night sky, as dawn can start as early as 3.00am.

The North Star, also known as Polaris, is the only star in the Northern Hemisphere that remains a point as all other stars rotate around it, so it is best to find it and point your camera at it for the full circular effect. The effect is similar in the Southern hemisphere too.

Below Left This shot shows the stars during a shorter exposure of five seconds. Any longer, and the stars would start to move. It is still possible to get some interesting star shots with shorter exposures.

Below Center and Right This exposure was about 1¹/₂ hours long and a 50mm lens was used.

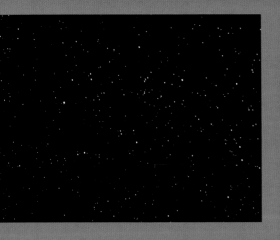

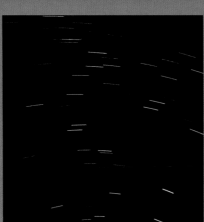

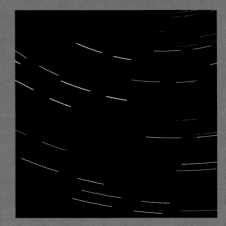

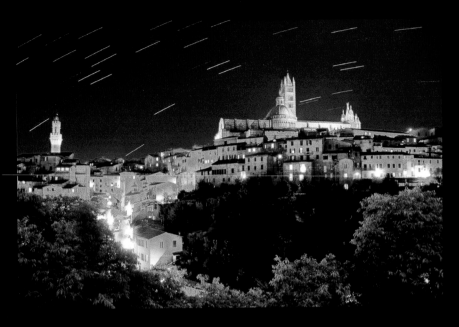

Left Here the exposure was about 30 minutes and has created a nice effect. The buildings were almost pitch black to the naked eye and it is only the extended exposure that has revealed detail. If some areas overexpose, bracket the exposures so you can pinch highlight areas from the darker exposures.

Shooting stars

You can shoot the stars without any other subject, but once you get the hang of it, try adding some foreground interest. Be careful not to overexpose it during the exposure, but remember you could take a few shots of the subject at the correct exposure and montage them in later. Even seemingly dark subjects can overexpose during very long exposures. In cold conditions, batteries may not last the entire session, so ensure you have backups or (if possible) an external battery pack.

Light pollution is a big problem in urban areas. Even the countryside can be polluted by light from big nearby cities. For really good shots, you need to be in the middle of nowhere where the sky really is pitch black, so be prepared to travel. If you do live in a city, you can still practice your technique as a "dry run," but the shots will often be ruined by street lights. Even in the countryside a full moon can cause flare and overexposure, so try to shoot when the moon is only a crescent.

TIPS FOR FLARE

Flare from a bright object will also ruin a long exposure. It often occurs in one corner of the frame. Using a lens shade will reduce any problems. Torches are a particular problem and you must take care not to shine them directly at the lens. The viewfinder is also a weak point and can leak light during a long exposure. Better cameras have a built-in cover that can be closed, but you can also buy a plastic adaptor to place over it.

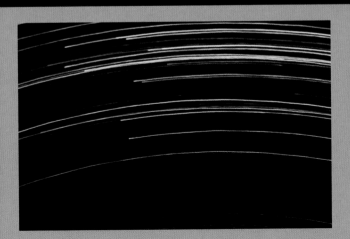

Left If you want to cheat, try photographing a fiber optic light, which has many thin fibers of light that look just like stars. Care has to be taken not to nudge the fibers during the exposure, or the trails will be wavy. You can then montage the trail into another photo.

Lightning

Lightning is one of Mother Nature's greatest showpieces. To capture it at all is incredibly difficult; and to capture it well, near impossible. Its elusive nature is made worse by the fact that if you blink you have just missed it! Without doubt, it is an excellent challenge for any photographer.

The best exposure

Lightning is somewhat like flash, where adjusting the aperture is the crucial way to alter the exposure. This means running some tests to determine which aperture works best. Use the slowest ISO setting, usually 100 or 200 for finest detail and grain, work with long exposures, and change the aperture until you get the desired results. For these shots I used an aperture of f16 and each exposure was about 20 seconds long. In darker areas, which aren't affected by too much light pollution, you can use the Bulb setting for much longer exposures. The more violent and frequent the lightning strikes are, the shorter the exposure can be. Do not waste time between exposures pondering the next strike, or you will miss it. Whichever exposure time you use, fire the shutter immediately after each exposure to make sure you don't miss any strikes.

For guaranteed results, you need to be in an area where lightning strikes are predictable. Hot, dry climates where storm clouds gather momentum during the day are ideal. By late afternoon, storm clouds are brewing, bringing with them torrential rain, thunder, and lightning—it can almost be timed by your watch. Central USA, Australia, and parts of Africa are well known for their storms. Cold, wet climates do get plenty of lightning but the time and place can be difficult to predict.

Below This series of shots was taken in Johannesburg, South Africa, not far from an area renowned for having the highest number of lightning strikes in the world, so I was in the right place! They were taken with a 400mm telephoto.

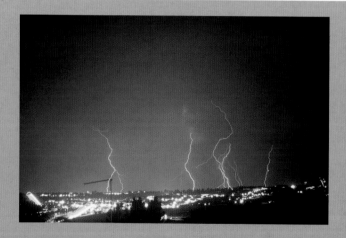
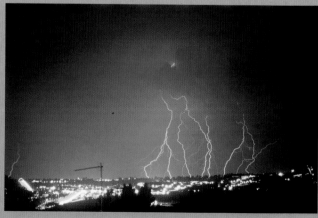

USING BLEND MODES

The magic of digital software has enabled me to combine all the shots into one amazing image. The secret is to use layers and blend modes.

First, I opened all the shots so they were on my Desktop, chose one shot for the final effect, and then dragged all the others onto this document to create several new layers. I then chose the aptly named Lighten blend mode for each layer, apart from the bottom Background layer. This blend mode looks at the color information of each channel and selects the lighter colors to remain unchanged while all darker colors are blended together. As a result, all light colors shine through from each layer.

Here the blended result was montaged with a cityscape. For a natural effect, always use similar focal lengths. Here both were shot with a telephoto lens between 200mm and 400mm.

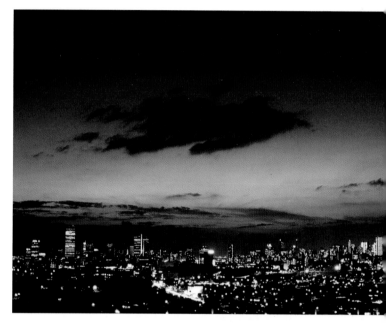

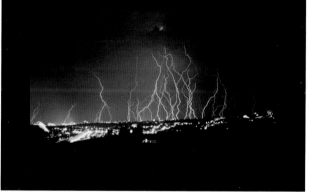

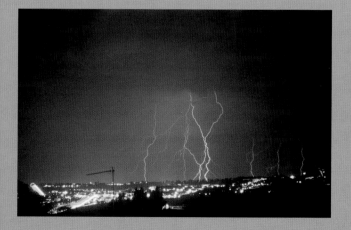

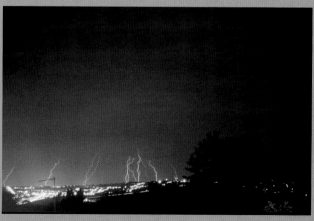

Light **trails**

One exciting phenomenon that occurs when you use long exposures is that anything moving in the shot becomes a blur. This can be used to your advantage with car lights. The bright lights record long thin trails as the cars pass—white with cars coming toward you and red with cars moving away from you—but the fast-moving cars don't record unless the traffic stops midway through an exposure. You need to set up your camera by the side of a busy road using a tripod for stability (though you can use a low wall or a post if you don't have one to hand).

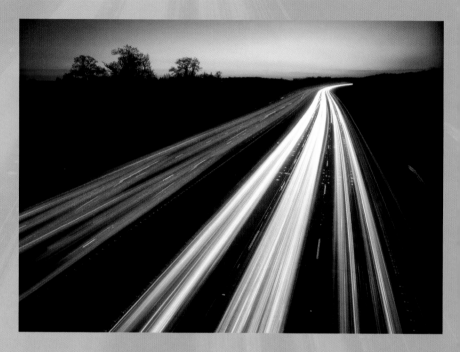

This was shot from a road going over a busy motorway at rush hour. The lens was a 21mm wide angle and the exposure was approximately 60 seconds at f16 at ISO 100. A cable release was used on the "B" setting and a black card used in front of the lens when there were no cars. The actual exposure was probably several minutes long.

Spend a few minutes gauging the best place to stand. You want to be where the traffic concentration is at its highest while maintaining a good overall composition. Ensure you don't place yourself in a dangerous position, and watch out for cyclists who ride close to the edge of the sidewalk—and even on it!

The best approach is to find traffic lights, wait for them to change to green, then fire the shutter as the first cars approach. The longer the exposure, the better, so stop your lens aperture down to get an exposure of 20 seconds or more. I tend to do several, bracketing the time upward slightly for each shot, and check it using the LCD display on the back of your camera. Alternatively, use the "B," or bulb, setting on the camera and keep the lens open for as long as you like.

With the "B" setting activated, hold a black card in front of the lens. This is useful if the traffic finishes but you want more car trails. Simply put the card in front of the lens and wait for the next change of traffic lights, then remove the card. The card must be a non-reflective black so it doesn't bounce light back into the camera when being used. A small piece of black velvet glued to a small 5x4" card will suffice. You can also use the card to block out buses when they pass. Buses can cause annoying streaks in the shot, potentially spoiling it or obscuring any buildings in the background.

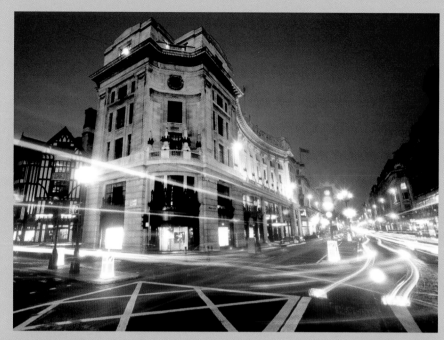

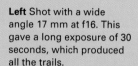

Left Shot with a wide angle 17 mm at f16. This gave a long exposure of 30 seconds, which produced all the trails.

Below Shot from a tall building looking over a bridge. Getting up high often gives a new slant on the world so look out for access to any tall buildings at night. It's often worth planning a trip.

TAKE IT FROM THE BRIDGE

Another approach is to shoot cars on a busy road from a bridge going over the road. You can get some fantastic trails doing this, which look like they are disappearing into infinity. Choose a location with a bend in the road for extra impact in the shape of the car trails. If you shoot near to rush hour, you are guaranteed lots of trails.

If you use a tripod, choose the lowest ISO your camera has (usually 50–200) to avoid getting noise in the shadows. If you must use a higher ISO setting, look for a noise-reduction facility in the camera, or eliminate it in software later on. Photoshop's Color Range tool is ideal here, as you can use it to quickly select similar areas of darkness automatically, then use a Gaussian Blur to reduce the noise.

Light **trails**

Exposure and white balance

The subject will always influence your final exposure settings. If you want to shoot buildings with traffic trails, you must get the buildings correctly exposed, or the final image will look awful. Take your exposure readings from the sky and midtones of the building, then adjust the aperture to get the longest exposure you can. If you shoot during the twilight crossover period, the exposure should be long enough for traffic trails to record naturally.

If shooting a busy road with no buildings, a longer exposure will be needed to capture detail. This will also enable you to capture more cars passing by, for a more dramatic effect.

You may find bracketing your shots helpful. Digital cameras have a tendency to clip highlight detail, especially in high-contrast night shots, so bracketing will enable you to take the best highlight and shadow details and add them to the best overall shot later on. White balance isn't a major issue for night shots unless you want a specific building to record naturally. If this is the case, you will need to check the rear LCD monitor and adjust the white balance settings. Remember: color casts are often what makes night shots so colorful and exciting, so don't remove them if you don't have to.

Below Shot at the famous bar Sloppy Joe's in Key West, Florida with a 35mm lens. The day shot is nice, but the scene really comes alive at dusk. I montaged several shots to get the traffic trails in the finished shot.

Opposite top I stood by the edge of the road and used the bridge arch as a frame. The green color is due to mercury vapor lighting, but this actually adds unexpected color and life into a shot. Shot with a wide angle 24mm at f11 for 20 seconds at ISO100. The vibration of the traffic going over the bridge ruined several shots, so I waited for heavy vehicles to pass before exposing.

Opposite bottom I stood in the middle of a dual carriageway to get this shot, which was a little dangerous! The sign was a great backdrop to the trails left by the cars. I added several extra red and white trails by copying and pasting onto new layers.

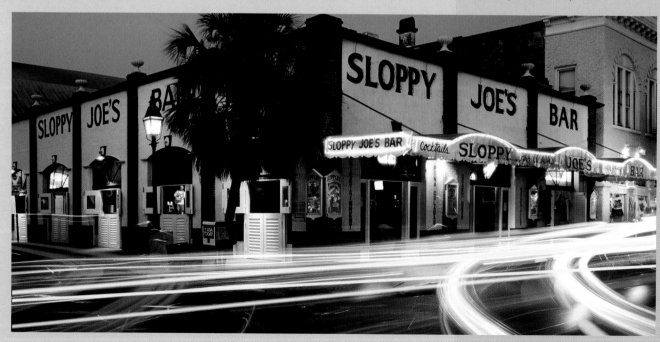

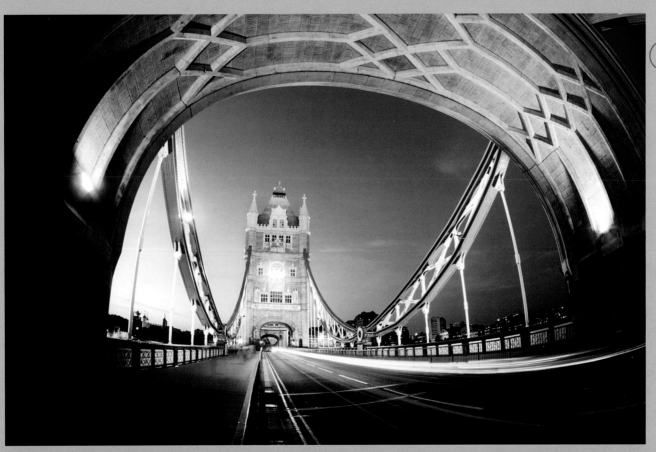

Cityscapes

Cityscapes are probably my favorite night-time subject. There is something magical about the power and energy that a panorama filled with lit buildings creates.

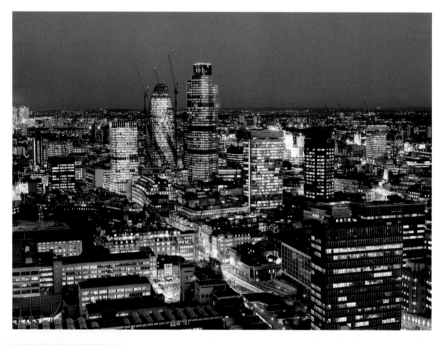

Right Shooting from skyscrapers is an awesome experience. Try to find public buildings that have viewing platforms, where you can take advantage of the height to shoot. You may often have to shoot in winter, as buildings will often be closed during summer months by the time it gets dark.

Below In this shot of HMS Belfast and St Paul's Cathedral at night, a long 210mm telephoto was used to bring the ship in really close. The telephoto has caused the perspective to compress, making everything seem on top of each other.

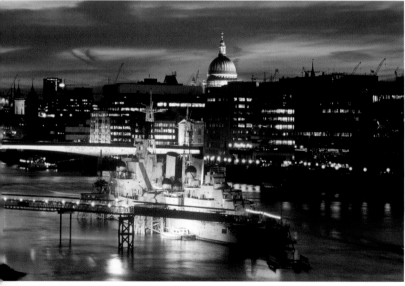

The secret to good cityscapes is location, location, location. Use postcards, books, and maps to check out potential locations, especially if you have only a few nights; don't waste your precious shooting time looking for something to shoot at the last moment! I usually pre-plan trips days in advance to increase my chances of success. This holds true for any location photography.

Many cities have rivers that run through the middle, or shores where water can become a major element within the photograph. Find these and use them to add reflections to your images. Another great way to get successful cityscapes is to get as high as possible. Use public buildings or apartment blocks if you can get permission, as height will give your picture a longer view and added impact.

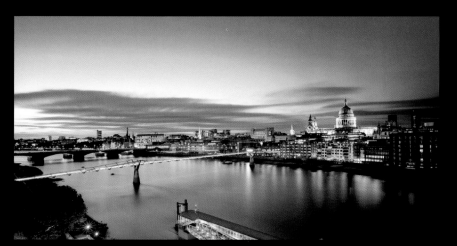

Top One of my personal favorites from recent times. The bridge had just been finished, but was about to be hung in scaffolding for months due to technical problems. The long exposure of 90 seconds at f22 has blurred the clouds nicely. It is similar to the effect long shutter speeds have on water, and here we have both water and sky. The small aperture has created the lovely star effect around the bright points of light.

Center Shot in Florence from the Plaza del Michelangelo: a favorite high viewing spot with many tourists (you need to arrive early to get a good position). Night photography is often about planning and waiting for that moment when it all gels perfectly. Here I set up one hour before sunset to shoot both sunset and dusk images.

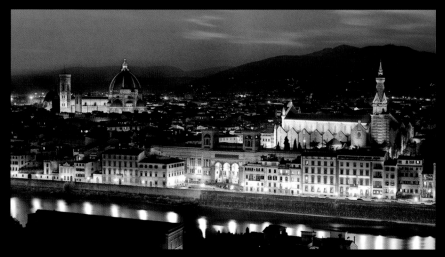

Bottom I shot this angle from the middle of the bridge to give a very symmetrical feeling to the shot. One problem with bridges is the vibration caused by lorries and buses. Place a black card over the lens until the bus has passed and the bridge has settled down again. This movement can be quite subtle, so use a level and check to see if the bubbles move.

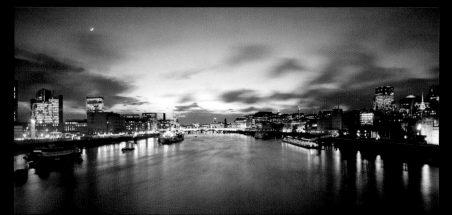

TIP

Try to capture the sunset as well as the dusk shot to maximize your time and energies. I often take two tripods to shoot two angles simultaneously with two cameras. An assistant (my wife!) helps enormously to cart the extra gear around, and acts as an extra pair of eyes on the camera gear.

Buildings

The urban landscape is one of the most exciting places to visit and take night shots. Most have a plethora of old and new buildings, often next to one another. The contrast between styles of old and new will give you many ways to interpret the subject, from straightforward shots to abstracts.

Many towns, especially very old ones, have small compact centers that can be accessed easily. When walking about, try to view a building from different angles, get up close and also from as far back as possible. Buildings look their best at dusk, especially if floodlit, so wait for the lights to become more dominant. If you shoot too early, it can look like a normal daylight shot, especially if overexposed.

It's worth the wait. It's exciting to see dull buildings you wouldn't look at twice during the day take on a new life once the lights come on, and the color of the light is all important. Do a series of shots using each white balance setting to see which one works the best, though if you shoot in Raw you only need to use Auto, as other modes can easily be selected using Photoshop's Camera Raw plug-in. This enables you to make critical color judgments in the comfort of your own home.

Floodlit buildings can be tricky to shoot, as there will be parts in shadow while other areas will be brightly lit. Use a spot meter to take a reading from a transitional area that is tonally in-between the two. Alternatively, take a reading from the sky midtones.

Make sure you try to keep some color in the sky, as it helps to differentiate all the shapes of the buildings against the sky. Once the sky has gone black, I generally look to shoot images that will look good in black and white.

Converging verticals

Converging verticals occur when the camera is pointed up or down away from a horizontal position. Sometimes converging verticals can create a strong dynamic force in a composition, but if you want your verticals to appear straight, moving further back will reduce their appearance. (See page 145 for advice on correcting them digitally.)

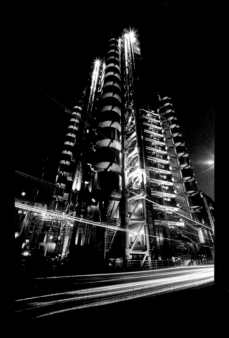

Below The London Stock Exchange is great as a wide angle shot but also using a telephoto. Here a 17mm wide angle lens at F11 with a shutter speed of 10 secs at ISO100 was used.

TIP

Flare can be a problem when shooting into bright lights, especially lights that are just out of shot where they can cause a flare burst. If shooting directly at strong lights, make sure the lens is spotlessly clean and, if your lens was supplied with a built-in lens hood, make sure it is fully extended or properly attached. A simple alternative is to use a small sheet of black card or your hand. Some experimentation will be needed to find the exact position so you don't inadvertently have the card protruding into a corner of the final image.

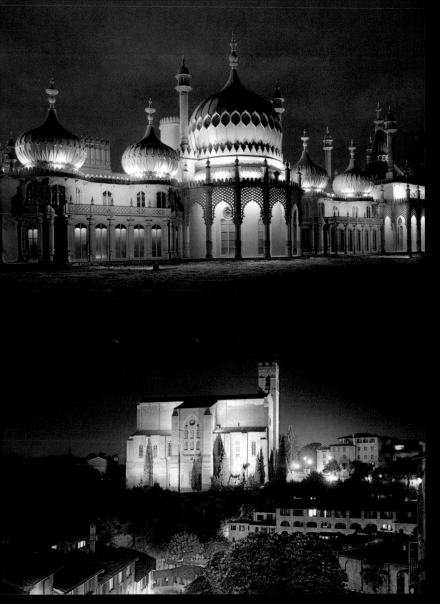

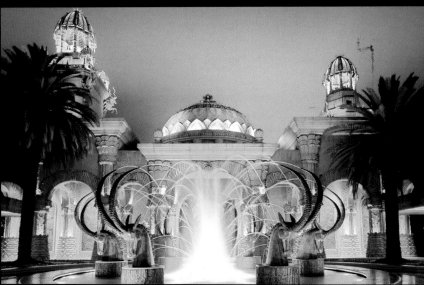

Above The generic view of London's Tower Bridge is to shoot it from one of the river banks to capture the entire structure, but here I decided to capture a detail of the bridge. The exposure was made difficult by large vehicles causing the bridge to vibrate, so I had to time my exposures during lulls in the traffic. A black card was used if a bus came along during the exposure, and I waited for the bridge to settle before continuing.

Top Left The Royal Pavilion, Brighton, England looks good during the day and even better by night! Elaborate lighting ensures the intricate architecture is shown off to maximum effect.

Center Left I noticed this church in Sienna as I walked over a small bridge, and used a telephoto to make it fill the frame. Some work was needed to bring out detail in the foreground. You can tell the exposure was very long, about 120 seconds, as the stars have become streaks.

Bottom Left This exotic setting is the entrance to the exclusive Palace hotel in Sun City, South Africa. The sky is real but was lightened later in Photoshop to create the final effect. A long exposure meant no people recorded in the shot as they walked in and out of the hotel.

Buildings

Right Industrial subjects are great for nighttime photography. The structures are often lit up and look far more interesting than by day. Often you will need to use a telephoto lens to get in close, as access can be restricted. Here the green mercury vapor lighting is in harmony with the blue sky (they lie next to each other on the color wheel).

Below The new lighting design on the Houses of Parliament has created a wonderful graphic image. I took this shot from Westminster Bridge, which meant I had to expose when buses had passed by. Otherwise, they caused the bridge to vibrate and blurred the image.

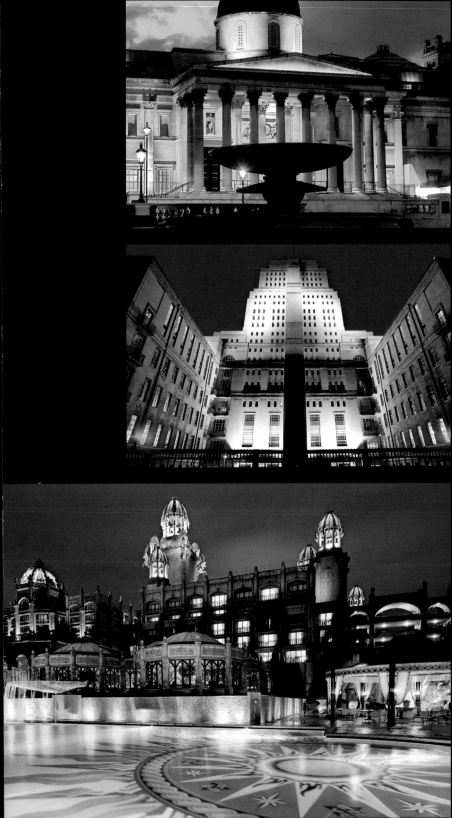

Mixed **lighting**

Right A series of lighting situations: London Bridge railway station is lit by green mercury vapor lights that add a spooky effect to this shot. Lloyd's Stock Exchange in London is a mecca for architectural photography. The modern design enables varied interpretation. Finally a boring road by day is dazzling by night due to the mixed lighting.

Lighting has a huge impact on your shot, which makes it difficult when you're shooting in mixed lighting conditions. This may just be daylight mixed with tungsten, or it could be a combination of sources including fluorescent, sodium, and mercury vapor lighting. Interior designers often use different types for their different qualities—fluorescent lighting is soft and voluminous whereas tungsten spots are bright and dazzling—but it doesn't make the photographer's life easier.

Traditionally a filter was needed to correct a color shift when using film, and for precise color correction a color meter and a bagful of very expensive filters was the order of the day. Luckily, digital cameras enable you to change the white balance settings depending on the type of lighting being used, and most will enable you to choose from several general settings.

To correct or not

One major dilemma when correcting mixed light sources is which color cast to eliminate. Eliminate one and you may add a color cast elsewhere. For example, if you add extra blue to an interior to remove the warm color cast of tungsten lighting, you could use a blue 80 series conversion filter or the appropriate Incandescent camera white balance setting. However, any daylight present will go even bluer, and this will either look attractive or ugly depending on the scene. Adding a magenta filter or Fluorescent setting to remove the green color cast of fluorescent lighting will make the daylight go magenta or purple. There is always a cost to correcting a color cast, which means it can be best to leave mixed color casts alone, as these usually add extra saturation and vibrancy to a picture anyway. This is particularly true of exteriors where there is plenty of natural daylight to dilute the artificial lights.

This is one of those subjects that you walk past during the day without a second glance. By night, however, it is turned into something far more special. The beautiful dusk sky sets off the yellow sodium street lights perfectly, to produce a surreal yet eye-catching result.

Color association

One way of rationalizing color casts is to ask if the color adds to or detracts from the image. A warm cozy restaurant looks odd if it doesn't have a lovely warm light enveloping the scene. Imagine it with a blue color cast, and it suddenly becomes uninviting. Green fluorescent lighting conjures up an association with industry, envy, greed, or illness, but green grass and trees create an impression of naturalness. Blue creates a mood of calm and coolness—we associate it with water and freshness. Reds and yellows are warm and inviting. A successful photographer understands how color association works and how it affects images.

Using Photoshop

Photoshop can be used to correct any color cast (although severe sodium yellow casts still pose a problem because the narrow yellow spectrum is so intensely saturated). This gives you another option in a mixed lighting scenario: to isolate and resolve each color cast one by one, using selections. Select the exterior windows of an interior, then invert the selection and you can remove the tungsten color cast without affecting the external daylight. This method can be used to clean up even complicated mixed lighting situations.

Below Shot in Santon, South Africa, this shopping mall had a grand entrance that looked like something from *Blade Runner*. The color casts added an ominous feeling to the shot, which I like. In fact, it's what attracted me to the shot in the first place.

Below left This hotel, shot on Mijas Golf in Spain, shows several different lights, all giving off different colors. The colors were left alone, as correcting one creates another problem and the overall effect is colorful anyway.

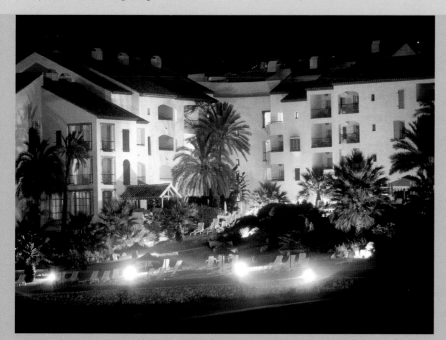

Street scenes

Don't confine yourself to photographing buildings and the usual sights at night, no matter how tempting it is to get as many shots as you can while the crowds are relatively quiet. Take the opportunity to shoot the streets around them. The street can add a new and exciting area within the composition, and bring a new perspective, motion, and blur to the shot.

Streets are dynamic places, full of cars on the road and people bustling around on the sidewalks. Use long exposures of 10 seconds or more to capture car trails, but try shorter exposures of a few seconds if you want to blur people. If the exposure is too long, the people won't register at all. Most streets get busy at rush hour, so aim to shoot at this time if possible. For this reason,, winter is often a better time to shoot street scenes, as fewer people are around when dusk occurs during the summer months.

Left Shoot detail shots of individual stores when they have plenty of interest to keep the viewer occupied. Here the colorful interior was matched by an equally colorful exterior and was irresistible to shoot.

Opposite This was shot in Southern Spain, where the Moorish influence on architectural design is still plain to see even today. 400 ISO was used to get a balance between speed and quality—I wanted to maintain some detail yet add a little blur for atmosphere.

Opposite top right This lively indoor street scene was shot at the weekend. It would have had less impact without the people, even though they are fairly blurred. An exposure of eight seconds at f16 gave sufficient depth of field and let the people blur for a more dynamic effect.

Opposite bottom right This was shot in the beautiful town of San Gimignano, Tuscany, Italy. The street was full of people, but a small aperture of f22 and a long exposure of 90 seconds meant they didn't register.

Neon lights and displays

Illuminated signs and huge displays of lighting are like candy to a child for photographers. The intense colors and bright hotspots make them ideal subjects.

All large cities and towns will have plenty of lights to choose from. Look out for restaurants, theaters, nightclubs and bars, which will almost inevitably have some sort of illuminated display to attract customers, as they are all places for night owls. The ultimate places to visit are towns like Las Vegas, Blackpool, or Tokyo, where entertainment is the main source of income. Here you will be spoilt for choice. If the sign is open to the sky, you can shoot it as the sky darkens; a deep-blue sky will contrast perfectly with the gaudy neon colors. Most signs will be set against a building, so use zooms to get the perfect composition.

Zooming in

One great technique is to zoom in during the exposure. Choose an aperture that will give an exposure of 4 seconds to 10 seconds, and compose the shot so the main part of the sign is in the middle of the frame. During the exposure, carefully and slowly zoom in. Vary the length of exposure, speed of zooming, and the focal length. For example, with a 70–00 zoom choose the following variations; 70-300, 300–70, 150–300, 300–150, 70–150, and 200–300. This will create some surprisingly different results.

You can get some great effects using the zoom exposure technique. Here I shot with a 70–210mm lens, zooming quickly during the 5 second exposure.

The famous Harrods store in London. It makes a fine study in itself, but I wanted to try a more dynamic variation.

I shot with a 70–210mm zoom lens, starting the exposure at the 70mm end and zooming quickly to 210mm. As the largest part of the exposure was at the 210mm end, the name has remained large, vibrant, and dominant. Zooming the other way would have left it faint.

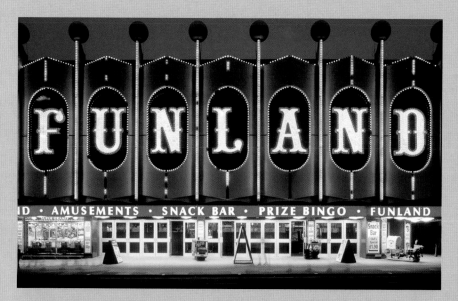

Shooting along the "Golden Mile" in Blackpool yielded many great shots full of the color and excitement of holidays and amusement arcades. The deep blue sky contrasts well against the vivid oranges and yellows of the tungsten lighting display. A 150mm lens was used for a 15-second exposure.

Piers are one of my favorite subjects for night-time photography, and Blackpool has three of them! Here I used pools of water on the beach at low tide to create a reflection. I was lucky there was no wind, as it would have destroyed the mirror effect.

Although not quite as glamorous as its inspiration in Paris, the Eiffel Tower, England's Blackpool Tower still makes a great subject to photograph. The brilliantly lit neon sign, illuminated building, and lights going up the sides make it a very colorful subject indeed. Here a 28mm lens was deliberately pointed up from close range to create a converging vertical effect. This acute perspective adds graphic impact and movement to the shot. The lights on the tower move upward in a sequence, so I had to count how long the sequence took to make sure all the lights came on during the exposure. If the lights took 40 seconds to reach the top and you used a 10-second exposure you would have to count to 30/35 before firing the shutter. This technique is often needed for lights that move in a pattern.

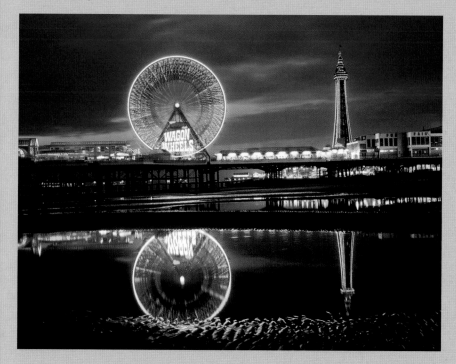

Fireworks

Fireworks are one of the most exciting and enjoyable spectacles you can photograph, and one subject you can take your family along to without being told to hurry up or that it's time to go!

Firework displays can be enjoyed all year round at one venue or another—check press details for special events, festivals, music concerts, and of course, traditional occasions like 4th July in the US, Bonfire Night in the UK, or New Year's Eve all over the world!

Although having a firework display at home is good fun, you will often be disappointed with the lack of firepower in the rockets. You need very big, powerful professionally made ones to get awesome colors and huge streaks. For this reason, go to big displays to get the best results.

Getting into position early is vital. The very first rockets are often the best as you don't yet have a build-up of smoke, which can ruin shots if there's no wind to blow it away. It will also be impossible to work out the best position without scouting around beforehand. Lots of people in the way is a disaster, as is one big head, so try and get there before the crowds arrive, and stand some way back in order to get a wider view of the display. With a wide angle lens you can get the entire display in the shot, or use a telephoto to fill the whole frame with explosions. You must use a tripod to keep the camera perfectly still during the long exposures, or the streaks will blur, causing the shot to be ruined. You can also use the tripod to quickly pan across from one part of the sky to another, as they often set the explosions off in different areas of the sky for effect.

Below Left The pier acted as the perfect backdrop to this display. It was shot during the summer, so a tinge of blue is still visible, which has set the colors off perfectly.

Below Center and Right Here, a 150mm telephoto lens was used to fill the frame with explosions.

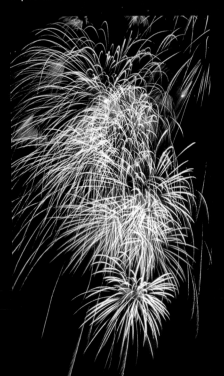
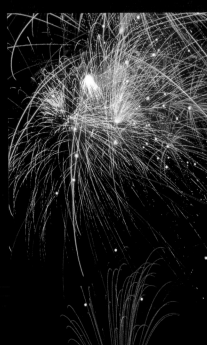
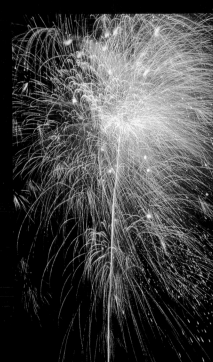

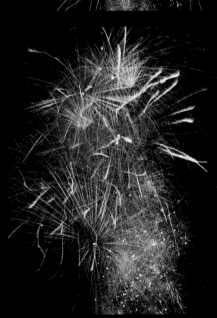

Getting the exposure right

I was quite surprised that my digital camera needed a very small aperture of f16 to f22 at ISO 200 for fireworks. The sensor is very sensitive to the bright streaks and over exposure is quite easy. Use the first explosions as a test for the correct aperture and also if the rockets are exploding in the center of your frame. It can be quite annoying to find you have only half the explosion in frame, so you must concentrate very hard at first to make sure the camera is pointing at the center of the display. Once in the correct position, you can use a long exposure of 10–30 seconds or the Bulb setting to keep the shutter open permanently. Use a cable release to minimize camera shake and enable you to concentrate on the bursts.

I vary the number of explosions per exposure. With some I have only one or two and some six or more. It is a gut decision that you must make at the time. Varying the numbers will give you more choice and a better chance of getting one perfect shot. Too few or too many will ruin the shot, but remember: with digital you can always montage several small bursts together later on, to make one big shot. If shooting on Bulb, you can place a sheet of black card in front of the lens during lulls in the display. This can be useful if you want to build up numerous explosions on one exposure without overexposing, especially if you have buildings in the shot.

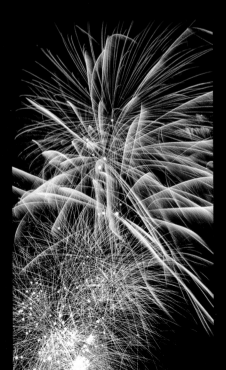

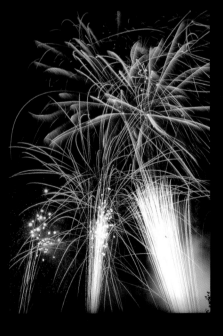

Above Here I used a wide-angle lens to capture the entire display, which enabled me to build up a number of explosions in one shot, using the black card technique.

Left The display marshal let me stand directly under the display as the fireworks exploded—a deafening but unforgettable experience. The acute angle looking directly up has resulted in a slightly different perspective.

Post-**Production**

Hardware and **software**

Without a computer and image-editing software, you're missing out on half the power of digital photography. Being able to adjust and manipulate color, tone, contrast, and sharpness is only the beginning; we can also crop and rearrange compositions, add new elements, and remove unwanted ones. To do this, we require a powerful computer that suits our own individual way of working.

Apple Mac vs. Windows PC

For most serious photographers, the biggest choice is between an Apple Macintosh or Windows PC. For many years, the Macintosh has been the mainstay of photographers, designers, and other creative professionals, thanks to a combination of high-quality software and built-in hardware that made the professional's life easier. Apple has worked hard to retain a lead in this market, its computers are well-designed and very user-friendly, and the OS X operating system is highly refined and very stable. However, PCs are now very capable, support the same image-editing applications and a wider range of hardware, while the latest version of the Windows operating system, Windows XP, is a vast improvement on previous versions in terms of reliability and ease of use. Personally, I have had fewer problems with my Mac and I would say I'm 50% more productive using it than I would be using a PC—the choice is up to you.

Processor speeds and extra RAM

The heart of any computer is the processor, usually rated in MHz. The actual MHz rating is actually slightly misleading, as a 2.4GHz Pentium 4 processor isn't faster than the 1.8GHz G5 processor used in a Mac. Computer magazines and websites can give you a clearer picture of how performance measures up, but a 1.42GHz G4 or 1.8GHz G5-based Mac is a sensible investment, as is a 2.8GHz or higher Pentium 4-based PC.

RAM is the next vital component, as it provides the high-speed store in which digital data is cached and processed while the processor works on it. The more RAM you have, the faster your system will be and the less time you will spend waiting while Photoshop completes complex tasks. 512MB is a sensible minimum these days, but 1GB will serve you better. RAM can be upgraded later, but your computer will have only a few memory slots, so buy the largest modules you can.

TIP

Positioning the computer

Avoid placing the computer in a sunny spot, where glare from the sun will make it difficult to view the image on the screen. Try to use a room that can be easily darkened with blinds or curtains, and use an anglepoise lamp (or a similar design) so you can position light away from the screen while working after dark. Some more expensive monitors include a hood to shield the screen from glare, but you can create your own from card and place it around your screen.

Graphics Tablets

A graphics tablet is one of the most useful accessories you can buy. These enable you to replace your mouse with a pen, which works on an electronic sensor pad designed to replicate the area of your screen. When you draw with the pen on the tablet, it works just like a mouse, except you can now use it like a pen or airbrush. This opens up a whole new world of effects, particularly when you use the brush tools in Photoshop. Not only is the pen more precise, but you can use it like an airbrush, allowing for many variations in angle and spray. Also, the pen is pressure sensitive—the harder you press with it, the more effect you have. For example, the brush tool will supply more paint over a wider area. This enables you to work on small details or airbrush in an entire sky. The more expensive models, usually from Wacom, have a higher level of pressure sensitivity for even more precise control.

Tim Gartside

© 2005

You can immediately see the difference between using a mouse and a Wacom Art Tablet. The writing in the first signature is smoother and more natural. When making detailed adjustments, this sort of control can't be overrated.

Tim Gartside

© 2005

An Apple G4 PowerBook is the ultimate computer for photographers who need image-editing power everywhere they go.

Scanners

Most people will have a box full of old slides and negatives from the good old days of film, or you may even be like me and switch between digital and film, depending on the type of photos you want. Either way, you may want to scan these in. The most economical route for occasional scanning is to send the film off to a lab and they will send a CD back to you with the scans on it. For larger volumes, it's more economical to purchase a dedicated scanner and scan in the film yourself.

The cheapest way to do this is on a flatbed scanner. These let you to scan both paper prints and film negatives (using a special adaptor). Until recently, the results weren't generally acceptable for professional use, but there are now some good flatbeds capable of publication-level results. Both resolution and dynamic range have improved dramatically, and low-contrast, low-detail images are now a thing of the past. But while flatbeds are ideal for medium format photography, where they scan a larger film area, there is a better answer for the smaller 35mm format.

This is a dedicated film scanner, and it's a particularly good bet if you intend to scan mostly film negatives. Most film scanners will have a superior quality lens, a high dynamic range from 3.8 up to 4.8, and fast scan times of around 30 seconds. Choose a model that best suits your film stock. If it is mostly 35mm film, you won't need to buy a medium format scanner for the occasional scan, which can be sent away. There are many designs on the market, and Nikon scanners usually do well in independent tests.

Flatbed scanners now double as capable slide scanners, though they still can't beat a specialized model for quality.

Software

Many cameras come bundled with some form of software that will enable you to download and even alter your images, but this is usually limited to reviewing images and basic corrections. For more advanced work, and fine-tuning of color and contrast, it's sensible to buy a more powerful image-editing application.

Like most professionals, I use Adobe Photoshop. It is, without doubt, the best image-editing application available, with many options that are essential for work in professional publishing, sophisticated color management, and the best array of tools for editing and transforming your images. Windows users have a popular alternative in Paint Shop Pro, which has many good tools and is a fraction of the cost, while budget-minded photographers will be perfectly well served by Adobe Photoshop Elements, which has the majority of Photoshop's features and a similar interface at a much cheaper price.

Adobe Photoshop

The application that all image-editing software is measured by. It has many tools, some of which will probably never be used by most photographers unless they are venturing into the world of publishing, which can make it complicated to master. However, it can be personalized extensively and streamlined to work with other popular Adobe products such as Illustrator, Go Live, and InDesign. It also supports an army of third party plug-ins that extend its functionality, some of which can be very useful to the photographer. Note that Photoshop is extremely memory-hungry: 1GB of memory is a sensible provision if you intend to make heavy use of the program.

Adobe Photoshop Elements

Photoshop Elements is essentially a cut-down version of Photoshop, with a few differences: notably the interface is easier to use for beginners and is more intuitive. Elements is competitively priced (around $80) and much cheaper than Photoshop (approx $550) and sometimes comes bundled with cameras and scanners. If you use Elements now, it will be easier to upgrade to Photoshop later, as many tools and functions are laid out in a similar fashion. However, you may not need to. With its excellent set of image-adjustment tools and powerful manipulation features, many photographers will be perfectly happy with Elements.

Corel Paint Shop Pro

This popular alternative to Photoshop —formerly JASC Paint Shop Pro—has been around for many years and built up a loyal following. It has many tools to rival Photoshop, but its cheaper price makes it a good entry level package for many photographers. The interface feels a little clunky in comparison to Photoshop, but it is quite easy to get used to with time.

Corel Painter

Painter is a different object altogether (many photographers will own both Photoshop and Painter), designed to create stunning fine art effects using simulated oil, pastels, and other artists' media. In the right hands, it can create fabulous results, and there are auto tools that do some of the work for you to get you going. The effects are great, but like all packages you need to spend time mastering the software to get good mileage from the program.

Third party plug ins

Many companies supply third-party plug-ins for Adobe products, especially Photoshop CS. Filters are the main item, designed to produce special effects that might be difficult to create using Photoshop's built-in tools. Others help with specific tasks. Extensis produce many quality software plug-ins that enhance Photoshop, including Photo Frame for unique edges, Intellihance Pro for general image enhancing, Mask Pro for complex masking, and Portfolio for image management.

Exposure and contrast corrections

Without doubt, this is the most common and important group of techniques you should master, as just about all images will be improved by a simple tonal makeover.

Creating selections

When doing any work on an image, you will invariably have to create a selection to enhance specific areas. This can be as simple as using the *Lasso* tool to draw a circle, or as complex as creating a *Quick Mask* selection. Choosing the right tool for the job takes practice and experience. The easiest tools—the rectangular and eliptical *Marquee* tools—are adequate for choosing regular areas of an image, but for other shapes you're better off using the *Polygonal Lasso* or—where there is a high level of contrast between the area you're trying to select and the background—the *Magnetic Lasso* or *Magic Wand*. Often overlooked, the *Color Range* tool works brilliantly when selecting portions of similar tone or color.

One useful tip for selections: feather them (*Select > Feather*). This softens the selection, and ensures any adjustment or manipulation will blend into the image as a whole. Often a low value of 2–5 pixels works best, but if it clearly looks fake, retrace your steps (*Edit > Undo*) and increase the amount.

SHADOW/HIGHLIGHT

This useful exposure tool enables you to make several changes that adjust for poor exposure at once. The default setting is meant to correct images where the subject is too dark and will usually need tweaking to get a favorable result. It is a quick way of lightening or darkening an image without using selections, but some images will work better than others.

The *Amount* setting changes the intensity of the effect, the higher the value the stronger the change. *Tonal Width* controls the amount of highlight/shadow tones that are changed. The higher the value, the larger the range of tones affected. *Radius* determines the extent of the change. Higher values tend to affect the image on a global level. *Color Correction* is designed to adjust for any color bleaching introduced by other adjustments in the dialog (and not a good tool for actual color changes). The higher the value, the more saturated the color becomes. *Midtone Contrast* does exactly what you might expect.

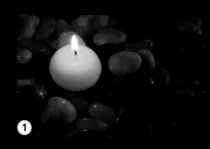

1 To alter the image, go to *Image > Adjustments > Shadow/Highlight*. The dialog opens and changes the image using the default settings as seen above. It has produced a washed-out image that lacks contrast.

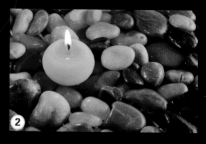

2 Alter the shadow settings first if the image is too dark and vice versa if too light. The *Shadow Amount* slider was increased to 64% to lighten the dark pebbles. The *Midtone Contrast* was increased from 0 to 58%. *Radius* was increased to smooth out the tones. To make the candle highlights darker, the *Highlight Amount* was increased to 78%, *Tonal Width* was decreased so only the candle was darkened, and the *Radius* increased slightly to 58%. The dark pebbles have been brightened effectively. This tool works particularly well on 16-bit RAW files where maximum data has been preserved.

1 This shot is slightly underexposed, but to preserve highlight detail I only want to fix a selected portion of the image. I used *Color Range* (*Select > Color Range*), clicking on a highlight and then clicking the + eyedropper in the dialog box to add more to the selection. Increasing *Fuzziness* using the slider also adds to the selection. With all the necessary highlights selected, click OK. The selection appears with Photoshop's "marching ants" surrounding it. Choosing *Select > Feather*, I feathered the selection by 4 pixels, then inverted the selection.

2 I can now use *Levels* to increase brightness and contrast, knowing the selection protects the delicate highlights from change, moving the black and white sliders in as shown.

3 I still felt the image needed something extra. The sky was selected using the *Magic Wand* and feathered 1 pixel. I then chose a brighter blue color from the *Swatch* palette, created a new layer and chose *Edit > Fill*, selecting the *Foreground Color* from the drop-down *Use* menu. The final result lifts the image to produce a more striking result.

Brightness/Contrast

The most basic exposure correction tool is the *Brightness/Contrast* command (*Image > Adjust > Brightness/Contrast*). However, it's also an imperfect one, and liable to make some problems worse. If you must use it, select an area of land or sky beforehand.

Levels

Levels (*Image > Adjust > Levels*) is a more flexible and powerful tool, particularly as you can work on individual color channels or work on the combined RGB color channel.

It works with a histogram, like those discussed on page 48–49. Just under the histogram are three triangular sliders that adjust the tonal values. The *White* slider brightens the highlights when moved in, the *Black* slider the shadows. When moved together, they increase contrast. The *Gray* slider in the middle changes the midtones. Move it left to brighten and to the right to darken. This is a more powerful way of changing the tonal values of an image, and by first selecting areas like skies, highlights, or shadows, it becomes even more precise.

Color balance corrections

You may want to remove a color cast that shouldn't be there or even add one to create an effect. Whatever your intention, there are various tools that can do an effective job.

Color balance

The *Color Balance* command is faster, but you don't get the comparison images. Simply move the sliders to add or subtract colors from the image. To remove a yellow tungsten cast, try shifting the *Yellow–Blue* slider to the right. To remove a green fluorescent cast, try shifting the *Magenta–Green* slider to the left. The *Highlights* may need more work than the *Shadows*, so fine-tune the results using the sliders in conjunction with the *Shadows*, *Midtones*, and *Highlights* radio buttons.

Variations and Color Balance

Image > Adjust > Variations is a super-intuitive color correction tool. The dialog box shows several different thumbnails, with the large *Current* box displaying the results of any changes made with the tool. Simply click on the relevant box to alter the overall color in that direction. In this case, I wanted to create a warm sunset feeling to this late afternoon shot of backlit trees, so I added extra *Red* and *Yellow* until happy. You can adjust colors from *Fine* to *Coarse* with the slider and also choose to confine color changes to *Shadows*, *Midtones*, or *Highlights*. All these options, plus the instant feedback, make *Variations* a very powerful way to alter color.

original image

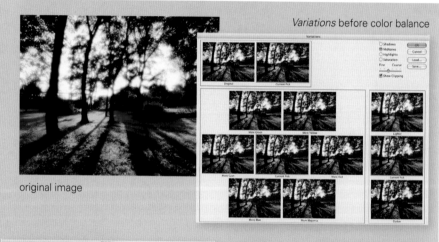

Variations before color balance

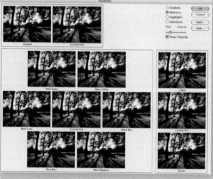

Variations after color balance

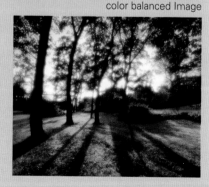

color balanced Image

Using Levels

Levels gives you color correction with pinpoint accuracy. There are two methods, which you can also combine if needed. This restaurant shot in Jamaica had all the right ingredients for a good shot, but the tungsten lighting has given it too much warmth.

Set Gray Point

In the *Levels* dialog box, you will see three eyedroppers. These are used to correct color casts. If you can find a neutral gray spot in the image, the *Gray* eyedropper in the middle works perfectly—just click on the area and the cast should disappear. Finding a true gray can be difficult, but here I used a shadow on a white tablecloth. If you are not sure, keep checking different areas until you find the best correction.

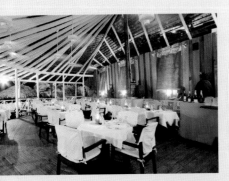

Correcting using the Set Black and White Points

An alternative is to use the *Black* eyedropper to select a black color and then do the same for the *White*. This will also correct a color cast and often increase contrast as well (you make the black pure black and the white pure white). However, care must be taken, or you may blow out highlight detail or lose too much shadow detail. Take your time and sample different areas before committing (with the OK button).

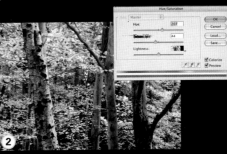

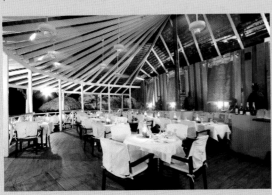

1 Tinting a shot is easy. This image was first converted to Grayscale to remove all color —this creates a high-contrast image with better defined tones of gray. I then converted it back to RGB mode. The *Hue/ Saturation* tools (*Image > Adjust > Hue/Saturation*) work well for bumping up the saturation of an image, but they also become useful here, creating an effect reminiscent of using a blue or sepia toner on a black-and-white print.

2 I opened the *Hue/Saturation* command and ticked *Colorize*, moving the *Hue* slider to 207 and the *Saturation* slider to 44. The *Hue* slider will create many subtle tones over a wide range of colors, and you can use the *Saturation* slider to alter their intensity. Don't touch the *Lightness* slider; this controls how dark or light each pixel is and normally isn't used.

Correcting **noise**

Noise is the digital equivalent of grain in a fast film, increasing as you change the ISO setting on your camera. In addition, you may get random noise from some cameras when shooting exposures of one second or more. These randomly spaced dots can often be brightly colored and stick out like a sore thumb. Some cameras have a NR or noise reduction filter that helps to eliminate random noise, but this won't cure high-gain ISO noise where the sensor sensitivity has been turned up.

1 Neat Image
The Neat Image dialog can be daunting. Using the *Preview* box, find an area of even tone (with no small details in it!) like the blue sky in this photo, and then fill the box with it. Select the *Auto Profile with: Regular Image* box and the software will automatically try to reduce the noise levels. Use this as a starting point and tweak the settings until happy.

2 Neat image filter
You can see from the comparison shots that the Neat Image filter has done an excellent job of removing grain, and the detail is still intact.

Older versions of Photoshop have three filters that try to reduce noise; Despeckle, Dust & Scratches, and Median. None really do the job particularly well because they destroy too much fine detail. CS2 owners have a better alternative—the new *Noise Reduction* filter—but a third party plug-in called Neat Image created by ABSoft does do a particularly good job and is reasonably priced. A free demo is available for both Mac and PC from www.neatimage.com, and the plug-in can be also used with Adobe Photoshop Elements.

The dialog box has many slider controls for fine-tuning the image and you can also load "device noise profiles" for specific devices like cameras and scanners, which are available as free downloads from their website. The most important slider is *Noise Reduction Amount:Y*, which changes the luminance channel. A preview box shows you an accurate idea of the finished effect. If dealing with a large file, try selecting a small area first with the *Rectangular Marquee* tool, which will speed up the filtering "test." Once happy, deselect the selection and apply to the whole image. This technique works well for many other tools as well.

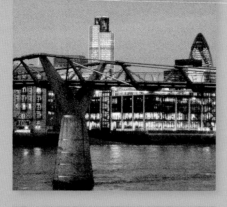

Fixing Noise

The original shot was taken at ISO 1600 and suffers from a lot of grain.

Despeckle filter

This basic Photoshop filter applies a simple despeckle, which reduces some noise. Repeated use will remove more noise, but any detail present will also degrade.

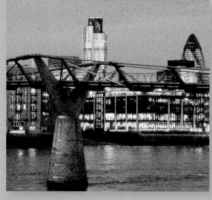

Dust and Scratches filter

Great care has to be taken with this filter, or it will destroy all fine detail. Bearing this point in mind, it fails to cope with removing grain at a low setting without removing the accompanying fine detail.

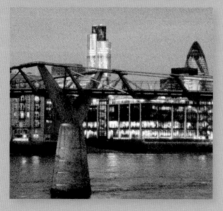

Median

I have used the Median filter to remove grain but only on skies, and using selections. Even then, too high a level will yield a strange edge effect that is hard to remove. Again, it cannot be used on fine detail without destroying it. Here I used a low setting of radius 2. It has failed to remove grain and has also lost fine detail.

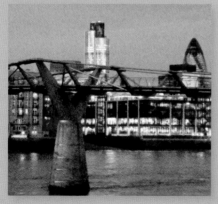

THE NOISE REDUCTION FILTER

With Photoshop CS2 (and Photoshop Elements 3, in fact) comes a new Noise Reduction filter, which users have long been clamoring for. By adjusting the sliders, you can attempt to achieve the best balance of noise reduction and preservation of detail. You can also opt for the advanced mode and make per-channel adjustments.

The filter also makes an appearance in the Camera Raw importer (CS2's tool for importing RAW files), where it can be guided by the file's metadata and make an informed decision. This is typically easier—and far more successful—though obviously you'll need a RAW file to work from in the first place.

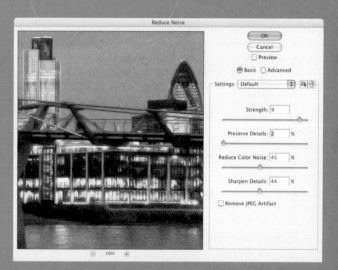

TIP

Adding Noise

You can, of course, deliberately add noise using the Noise filter (*Filter > Noise > Add Noise*) to mimic fast grainy films. The Grain filter (*Filter > Texture > Grain*) creates a softer, more impressionistic effect reminiscent of a painting and can look fantastic on the right type of image. Try it on simple, bold monochromatic images for best effect.

Image **retouching**

finished image

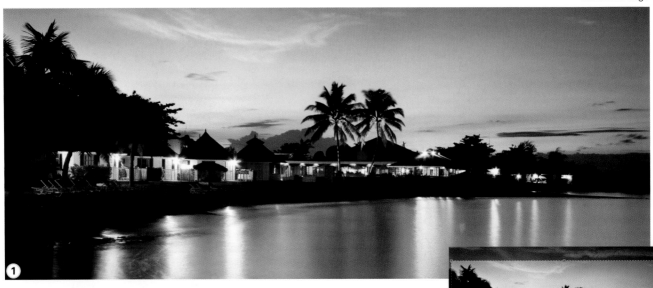

Crop tool

1 The *Crop* tool enables you to quickly and easily remove unwanted areas from a photograph. This is particularly useful when you have distracting elements that have crept into the side of the shot, or you want to create a panoramic or other crop and place emphasis on a subject that is too small in the original so that it becomes the focal point. The *Crop* tool can be found on the main toolbar. Always save the cropped document as another name to preserve the original. If you don't, the cropped area will be permanently lost.

2 Select the *Crop* tool and drag the mouse from the top left corner of the photo to the bottom right corner. A selection of marching ants appears, called a bounding box or crop marquee, with handles in all corners and the middle. Drag each handle individually to create a new crop shape. Here I have created a letterbox panoramic to give the image a more modern feeling. To constrain the proportions to the original shape, hold down the Shift key while dragging. You can drag inside the new bounding box to reposition the crop.

original image

Although we all try to create a perfect shot in camera, there are many times when an image needs alteration, ranging from a small tweak to major surgery. Here are several techniques that will improve your shots in post production.

Correcting converging verticals

One of the most common problems when shooting buildings is that you cannot move far enough back, and verticals bend in, which can look strange. This can be easily corrected using Photoshop's *Crop* tool.

1 As before, drag the mouse across the image. Tick the box marked *Perspective* from the *Options* bar at the top of the screen. This enable you to alter perspective rather than crop the image.

2 Now drag the top corner handles so that the marching ants are parallel with your verticals. Do this on both sides. You can move the entire line in, to fine-tune the angle, but remember to drag it back out again to the edge of the image, or it will remove too much image. When you're happy, click the checkmark in the *Options* bar and consider those verticals fixed.

finished image

Adding a new sky

1 Sometimes you find yourself disappointed by the sky in your shot, particularly if your exposure wasn't perfect during shooting and it has over- or underexposed. Don't worry. You can always add a sky from another image. Make sure the Background layer has been changed to an editable one by double-clicking it and that both images are open on the desktop. Here the sky was selected as normal with the *Magic Wand* tool, feathered by 5 pixels to soften the edge transition, and removed using *Edit > Clear*.

2 This left a transparent area for the new sky to go into. I opened another image containing a better sky. The new sky was dragged across with the *Move* tool, and it automatically created a new layer. This was placed underneath and resized, using *Edit > Transform > Scale*. Once the position was correct, I flattened the layers (*Layer > Flatten Image*).

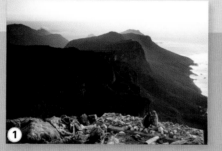

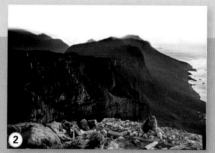

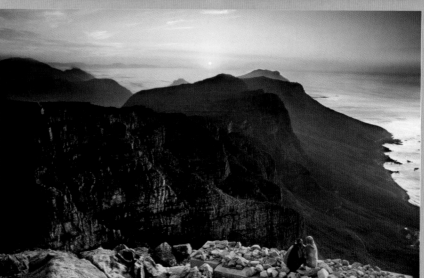

finished image

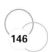

Color to **black**-and-**white**

Although color is the predominant medium in photography, the art of black-and-white is still very popular as it can create a completely different feeling to your images. The removal of color enables us to see the subject in a more analytical manner, without the distraction that color brings.

Digital photographers are very fortunate, as you can easily turn a color image to black-and-white at the press of a button. This gives you two options to choose from and if an image isn't working in color, it's always a good idea to see how it looks in black and white. If you add on color tints and Duotones, the list of options is quite large. There are several different ways of converting color to monochrome in Photoshop.

The color original, and monochrome variants using *Desaturate* (left) and *Grayscale* mode (right).

The Desaturate command

The easiest is to go to *Image > Adjust > Desaturate* or use the keyboard shortcut Command/Cntrl + Shift +U. However, while this may be the easiest option, it's also the least satisfying from a tonal point of view. As you can see, the tones are flat and dull. This is a rather lazy way of getting rid of color, and it shows.

Grayscale Mode

Try again, but this time go to *Image > Mode > Grayscale*. Here the colors have separated into much more distinct tones, and this is the best way to get a black-and-white image without any serious tonal shifts. The reds and yellows are much better defined in the foreground of the shot.

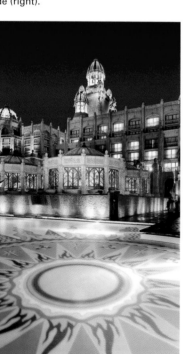

original image

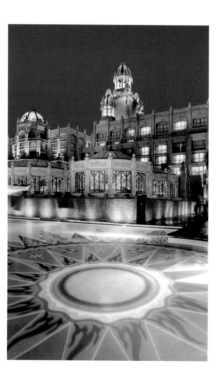

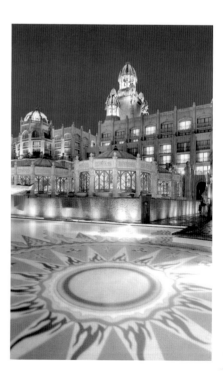

Channel Mixer

There is a better way, though. Go to *Image > Adjust > Channel Mixer* to create a more distinctive tonal range that is reminiscent of using a colored filter over the lens with black-and-white film. You must tick the *Monochrome* box and choose a *Red, Green,* or *Blue* output channel. Here, using the *Red* channel gives us a stronger contrast than a grayscale conversion. The blues have gone far darker, while the reds obviously go lighter. With an image with more red or yellow, try different channels or tweaking the sliders.

If you use the *Green* channel, greens go lighter and in the *Blue* channel blues go lighter and reds darker. This is a very powerful tool that allows many tonal variations to be quickly tried out. Tick the *Preview* box to see the effects in real time.

Tip
A few cameras offer Grayscale mode as a shooting option these days, but if it does, always use the color mode. You can easily convert to mono later from a color image, but you cannot ever convert a mono shot to color.

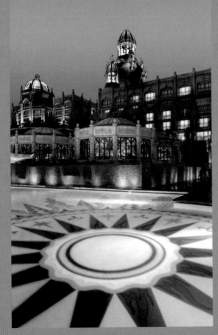

blue channel

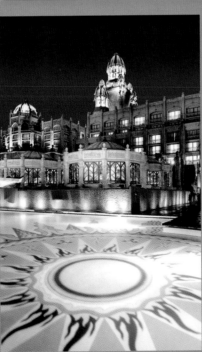

green channel

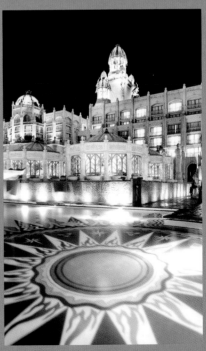

red channel

Day to **night**

It's not always possible to shoot at night, but you can replicate some of the effects of night photography on a daylight shot using Photoshop.

Turing day to night

It's difficult—if not impossible—to create a perfectly convincing effect, but this day-to-night technique is good way to spice up an otherwise unengaging daylight photograph.

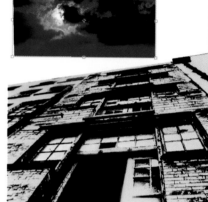

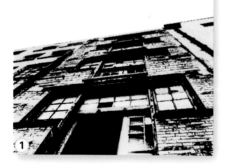

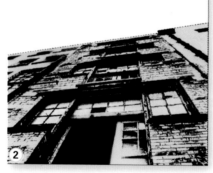

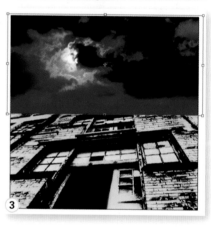

1 The original shot was a black-and-white negative, which was scanned in and cropped square. The sky was featureless due to an overcast day. To remove any color, the image was converted to grayscale (*Image > Mode > Grayscale*) and then back to RGB (*Image > Mode > RGB*) so a new color could be added.

2 The white sky was selected with the *Magic Wand* tool and *Select > Save Selection* was used to save it as an alpha channel that could be used later on. The selection was then inverted, using *Select > Inverse* to select the building so it could be colored. I used the *Hue/Saturation* command and ticked the *Colorize* box to create a blue color. *Saturation* was 100% and *Hue* was 216. The blue gave a nice night time feel to the image.

3 A new sky was imported and the same technique was used to colorize it blue. The sky also had to be re-sized, using the *Edit > Transform* tool. I held down the Shift key when dragging the sky to maintain proportion. Using *Select > Load Selection*, the sky selection was reloaded and the white sky was then removed with *Edit > Clear*. Make sure the building layer is selected to do this, or you will delete the sky layer instead! The new sky layer was placed below the building layer and moved into its final position using the *Move* tool.

4 To make the final image look more authentic, I added some orange color to make the windows look illuminated. This was time-consuming, as I had to select each window using the *Polygonal Lasso* tool. I did a small group at a time to make life easier, creating multiple selections using the *Add To* selection button in the *Tool Options* bar. I then picked an orange color from the *Swatch* palette and used a small, low opacity *Brush* to paint on the color. I then changed the blend mode in the *Tool Options* bar to *Color* to maintain grayscale detail underneath (*Normal* mode would just paint over it). With one color finished, I added a slightly darker orange color to portions of each window to add a little more realistic depth to the image.

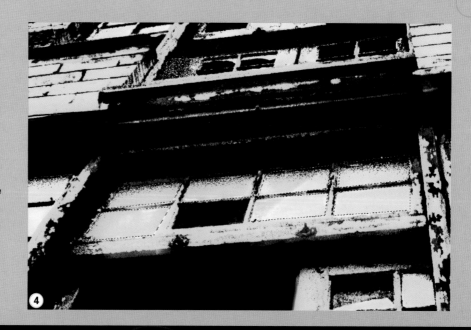

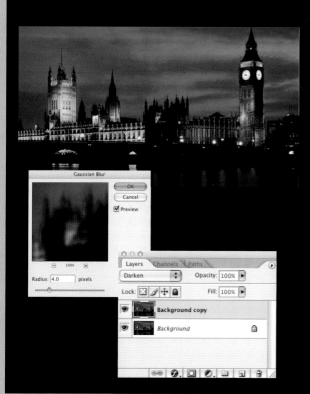

TIP

Use the blend mode options for some really interesting effects. It is found in the *Layers* palette, with the drop-down menu normally showing (you guessed it) *Normal*. Note that you need at least two layers to make them work and that blend modes work on layers below, not those above. There are many effects and the best way to appreciate them is to try each one out to see what effect it has on the image. Try duplicating a layer (*Layer > New Layer via Copy*), adding a subtle *Gaussian Blur* to it, and then changing the blend mode to *Darken* for a nice effect.

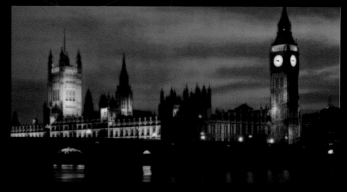

Photoshop **special effects**

Photoshop and similar software packages enable you to create some amazing effects. Here are a few ideas to try, which will hopefully give you inspiration to experiment more.

Motion Blur filter

Here I've tried to recreate the effect of using flash to freeze a moving object. Front curtain sync fires the flash at the beginning of the exposure so the subject has the streak in front while rear curtain sync fires the flash at the end of the exposure resulting in the streak behind the subject. For most moving objects using rear curtain flash creates a more natural flow to the image.

2 Make the copy layer active and use *Edit > Transform > Scale* to drag only the side handle bars outward. This will stretch and distort the copy layer. Now go to *Filter > Blur > Motion Blur* and use a *Distance* setting of 807 and an *Angle* of 0° to keep the effect horizontal.

1 Create a new layer of the boat and go to *Image > Canvas Size*. Now extend only the image width from 11.3" to 16" to create a panoramic shape. This has created extra space in the canvas, enabling the image to be stretched.

3 You now have the original boat on one layer and the motion blur on another. Go back to the original boat layer and use the *Magic Wand* tool to select all the black background. *Feather* the selection by 5 pixels and choose *Edit > Clear* to leave the boat on a transparent background. Place this layer above the motion blur layer. The boat can now be moved to the left or right. Use the Lighten Blend Mode to add a transparent effect, or the boat will look cut-out and fake.

③

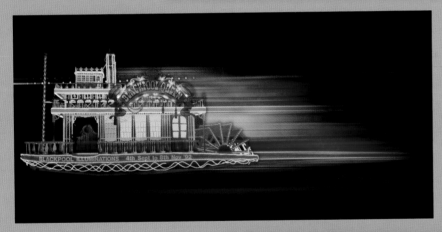

With the Lighten Blend mode chosen the boat blends seamlessly with the background to create an eye catching image. The boat can be placed at the beginning of the blur for a front curtain flash sync effect and at the end for a rear curtain flash effect.

Photoshop **lighting effects**

Photoshop's Lighting Effects filter offers us an easy way of adding interesting lighting to a shot in post-production. These are just two examples—spend time experimenting, and you will find many more.

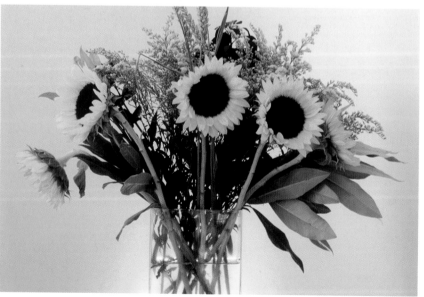

1 You can find the *Lighting Effects* filter in the *Render* category of filters. When the dialog opens, you will be confronted by a vast array of drop-down menus and sliders, which makes the filter look horribly complicated. Once you have played around with the options, it's fairly easy to understand how they work. The main choice is which *Style* to choose and which *Light Type*. Here I have opted for a straightforward example with the *Style* left at defaults. I chose *Spotlight* from the *Light Type* menu. The next step is to alter the shape of the light. Use the middle white center circle to move the light about the image. The side handles will alter the width and length of the light effect. You can also use the top or bottom handle to rotate the light around the axis of the white center circle.

Play around with each slider until you understand how each one works. This is often the best course of action with many of Photoshop's dialogs.

- *Intensity* alters the strength of the light.

- *Focus* alters the width of the beam from Narrow up to Wide.

- *Gloss* reduces or increases surface reflections from low (matt) to high (glossy).

- *Material* alters the way the color is reflected.

- *Plastic* reflects the color of the light if you have chosen a color from the *Color Picker*.

- *Metallic* reflects the color of any objects into the scene.

- *Exposure* increases or decreases the lights effect. 0 has a neutral effect. It will affect all lights at once. Use the *Intensity* slider to alter the effect of each individual light.

- *Ambience* creates a more intense general light effect. It adds a diffused external light source that alters the entire image, not just within the bounding box of each light.

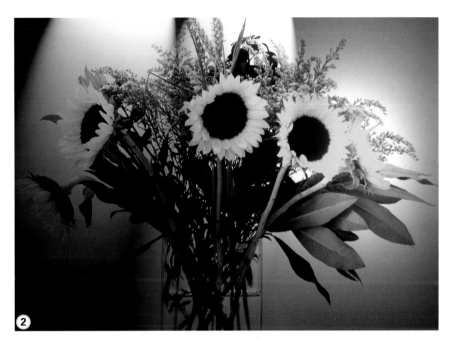

2 The next example shows a more complicated lighting effect. Here *Three Down* was chosen from the *Style* menu (there are seventeen different lighting effects to choose from). You can now move and alter each of the three light sources individually to create a precise effect. If you like the final effect, use the *Save* button to store it for future use.

How to digitally montage a moon into a shot

Photoshop enables you to do many complex montages, but these are really subject for another book. For night photography, however, one simple montage always comes in useful: adding a new moon to an existing shot. While the moon is a beautiful subject in its own right, you would need to have access to a very powerful telescope to get the magnification and detail needed to make it a subject on its own. With a telephoto lens, enough detail can be captured to make it work brilliantly in combination with another night subject. As you can alter the size of the moon, it enables you to create some powerful images.

Selecting the moon

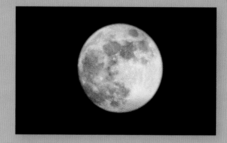

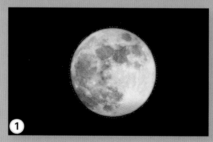

1

2

1 Firstly open the two shots—the moon and your chosen night shot. You can add a moon to just about any shot you like, but it will need to have the *Levels* corrected slightly to produce the best result (see page 139). It now needs to be separated from the black sky. This is an easy job, as you just select the black sky with the magic wand tool. Now choose *Select > Modify > Expand* and expand the selection by 3 pixels so no black sky is left around the edge of the moon. This stops the moon looking obviously cutout against a sky of a different color (this is not necessary when the two backgrounds are of a very similar color). Feather the selection by 1 pixel to soften the edge, but don't feather too much, or you will lose the edge of the moon.

2 You need to transform the moon layer from the background layer into one capable of transparency. Drag the Background layer to the *Create a New Layer* icon at the bottom of the *Layers* palette to make a copy (or double-click its layer name and re-name Layer 0), and it will be placed as a new editable layer. Now go to *Edit > Clear* to remove the black sky, and then throw away the old background layer to the *Delete Layer* (trash) icon. This will leave you with a moon on a layer with a transparent background. Save your moon as a .Tiff or .PSD file to preserve the transparent layer. This moon can now be used on any future night project. Simply drag the moon layer to your new document, and it will appear on its own layer.

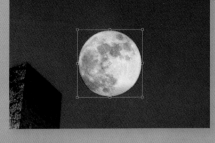

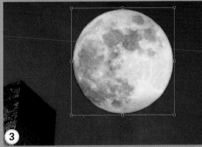

3 The moon can be resized by going to *Edit > Transform > Scale* and using the corner handle bar to drag the moon to a new size. Hold down the Shift key to constrain the proportions. Simply use the *Move* tool to drag the moon to your favored position and flatten the layers. You can alter the color of the moon with *Image > Adjust > Hue/ Saturation*. Pick a color that suits the mood of the shot.

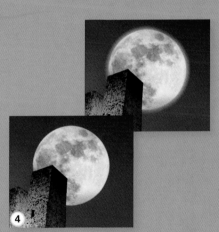

4 The moon often has a natural glow or halo around it, especially when there are ice crystals in the air. This can be mimicked using *Gaussian Blur*. Make a duplicate layer of the moon, and then make the bottom layer active by clicking it. Now apply the *Gaussian Blur* filter with a 30 pixel value. The moon detail is blurred and it becomes slightly larger, giving a nice glow effect. Duplicate the blurred layer again for a stronger effect.

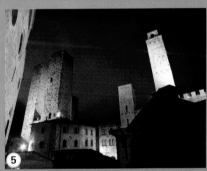

5 The moon can be made to look more three-dimensional by placing it behind an object within the picture. To do this, select an area of the background image and copy it to a new layer. Now place the moon layer in between the two layers. In this example, I first selected the sky with the *Magic Wand* tool, as it is a solid single colored tone. I then inverted the selection, feathered it by one pixel, and copied it onto a new layer using *Edit > Copy* and then *Edit > Paste*. You won't see any difference unless you move the new layer, but it must remain in perfect registration to work, so don't touch it. The moon layer was then placed in-between like the meat in a sandwich. It could now be moved to any position behind the buildings.

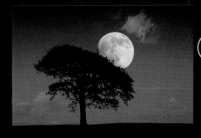

I knew the location of this tree well, having photographed it several times before. It was shot with a moon in it, but I added this one and made it very large for extra impact.

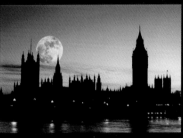

The original shot was nice, but I knew that a full moon would add to the shot. It was shot with a 100mm telephoto lens and exposed for 3 seconds at F11. Both color and contrast were boosted in the sky.

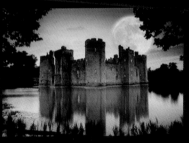

Shot with a moderate 35mm wide angle lens. The trees are real, as is the sky, but the reflection and moon were both added. The lights in the windows were also added later. The moon was added using the same technique as the San Giminano example on the left.

Glossary

aperture The opening behind the camera lens through which light passes on its way to the CCD.

artifact A flaw in a digital image.

backlighting The result of shooting with a light source, natural or artificial, behind the subject to create a silhouette or rim-lighting effect.

bit (binary digit) The smallest data unit of binary computing, being a single 1 or 0.

bit depth The number of bits of color data for each pixel in a digital image. A photographic-quality image needs eight bits for each of the red, green, and blue channels, making for a bit depth of 24.

bracketing A method of ensuring a correctly exposed photograph by taking three shots; one with the supposed correct exposure, one slightly underexposed, and one slightly overexposed.

brightness The level of light intensity. One of the three dimensions of color in the HSB color system. See also Hue and Saturation

byte Eight bits. The basic unit of desktop computing. 1,024 bytes equals one kilobyte (KB), 1,024 kilobytes equals one megabyte (MB), and 1,024 megabytes equals one gigabyte (GB).

calibration The process of adjusting a device, such as a monitor, so that it works consistently with others, such as scanners or printers.

CCD (Charge-Coupled Device) A tiny photocell used to convert light into an electronic signal. Used in densely packed arrays, CCDs are the recording medium in most digital cameras.

channel Part of an image as stored in the computer; similar to a layer. Commonly, a color image will have a channel allocated to each primary color (e.g. RGB) and sometimes one or more for a mask or other effects.

CMOS (Complementary Metal-Oxide Semiconductor) An alternative sensor technology to the CCD, CMOS chips are used in ultra-high-resolution cameras from Canon and Kodak.

color temperature A way of describing the color differences in light, measured in Kelvins and using a scale that ranges from dull red (1,900K), through orange, to yellow, white, and blue (10,000K).

compression Technique for reducing the amount of space that a file occupies, by removing redundant data.

contrast The range of tones across an image, from bright highlights to dark shadows.

cropping The process of removing unwanted areas of an image, leaving behind the most significant elements.

depth of field The distance in front of and behind the point of focus in a photograph, in which the scene remains in acceptable sharp focus.

diffusion The scattering of light by a material, resulting in a softening of the light and of any shadows cast. Diffusion occurs in nature through mist and cloud cover, and can also be simulated using diffusion sheets and soft-boxes.

edge lighting Light that hits the subject from behind and slightly to one side, creating flare or a bright "rim lighting" effect around the edges of the subject.

feathering In image-editing, the fading of the edge of an image or selection.

file format The method of writing and storing information (such as an image) in digital form. Formats commonly used for photographs include TIFF, BMP, and JPEG.

fill-in flash A technique that uses a flash in combination with natural or ambient light to reveal detail, say where the subject is before a bright view, and reduce shadows.

filter (1) A thin sheet of transparent material placed over a camera lens or light source to modify the quality or color of the light passing through. (2) A feature in an image-editing application that alters or transforms selected pixels for some kind of visual effect.

focal length The distance between the optical center of a lens and its point of focus when the lens is focused on infinity.

focal range The range over which a camera or lens is able to focus on a subject (for example, 0.5m to Infinity).

focus The optical state where the light rays converge on the CCD to produce the sharpest possible image. This is often achieved automatically using "AF", auto-focus.

fringe In image-editing, an unwanted border effect to a selection, where the pixels combine some of the colorsinside the selection and some fromthe background.

f-stop The calibration of the aperture size of a photographic lens.

gradation The smooth blending of one tone or color into another, or from transparent to colored in a tint. A graduated lens filter, for instance, might be dark on one side, fading to clear on the other.

grayscale An image made up of a sequential series of 256 gray tones, covering the entire gamut between black and white.

haze The scattering of light by particles in the atmosphere, usually caused by fine dust, high humidity, or pollution. Haze makes a scene paler with distance, and softens the hard edges of sunlight.

histogram A map of the distribution of tones in an image, arranged as a graph. The horizontal axis goes from the darkest tones to the lightest, while the vertical axis shows the number of pixels in that range.

hot-shoe An accessory fitting found on most digital and film SLR cameras and some high-

end compact models, normally used to control an external flash unit.

HSB (Hue, Saturation, Brightness) The three dimensions of color, and the standard color model used to adjust color in many image-editing applications.

hue The pure color defined by position on the color spectrum; what is generally meant by "color" in lay terms.

ISO An international standard rating for film speed, with the film getting faster as the rating increases. ISO 400 film is twice as fast as ISO 200, and will produce a correct exposure with less light and/or a shorter exposure. However, higher-speed film tends to produce more grain in the exposure, too.

lasso In image-editing, a tool used to draw an outline around an area of an image for the purposes of selection.

layer In image-editing, one level of an image file, separate from the rest, allowing different elements to be edited separately.

light tent A tent-like structure, varying in size and material, used to diffuse light over a wider area for close-up shots.

luminosity The brightness of a color, independent of the hue or saturation.

macro A mode offered by some lenses and cameras that enables the lens or camera to focus in extreme close-up.

mask In image-editing, a grayscale template that hides part of an image. One of the most important tools in editing an image, it is used to limit changes to a particular area or protect part of an image from alteration.

megapixel A rating of resolution for a digital camera, directly related to the number of pixels forming or output by the CMOS or CCD sensor. The higher the megapixel rating, the higher the resolution of images created by the camera.

midtone The parts of an image that are approximately average in tone, falling midway between the highlights and shadows.

monobloc An all-in-one flash unit with the controls and power supply built-in. Monoblocs can be synchronized together to create more elaborate lighting setups.

noise Random pattern of small spots on a digital image that are generally unwanted, caused by nonimage-forming electrical signals.

pixel (PICture ELement) The smallest units of a digital image, pixels are the square screen dots that make up a bitmapped picture. Each pixel carries a specific tone and color.

plug-in In image-editing, software produced by a third party and intended to supplement a program's features or performance.

ppi (pixels-per-inch) A measure of resolution for a bitmapped image.

reflector An object or material used to bounce available light or studio lighting onto the subject, often softening and dispersing the light for a more attractive end result.

resampling Changing the resolution of an image either by removing pixels (lowering resolution) or adding them by interpolation (increasing resolution).

resolution The level of detail in a digial image, measured in pixels (e.g. 1,024 by 768 pixels), or dots-per-inch (in a half-tone image, e.g. 1,200 dpi).

RGB (Red, Green, Blue) The primary colors of the additive model, used in monitors and image-editing programs.

saturation The purity of a color, going from the lightest tint to the deepest, most saturated tone.

selection In image-editing, a part of an on-screen image that is chosen and defined by a border in preparation for manipulation or movement.

shutter The device inside a conventional camera that controls the length of time during which the film is exposed to light. Many digital cameras don't have a shutter, but the term is still used as shorthand to describe the electronic mechanism that controls the length of exposure for the CCD.

shutter speed The time the shutter (or electronic switch) leaves the CCD or film open to light during an exposure.

SLR (Single Lens Reflex) A camera that transmits the same image via a mirror to the film and viewfinder, ensuring that you get exactly what you see in terms of focus and composition.

snoot A tapered barrel attached to a lamp in order to concentrate the light emitted into a spotlight.

soft-box A studio lighting accessory consisting of a flexible box that attaches to a light source at one end and has an adjustable diffusion screen at the other, softening the light and any shadows cast by the subject.

spot meter A specialized light meter, or function of the camera light meter, that takes an exposure reading for a precise area of a scene.

telephoto A photographic lens with a long focal length that enables distant objects to be enlarged. The drawbacks include a limited depth of field and angle of view.

TTL (Through The Lens) Describes metering systems that use the light passing through the lens to evaluate exposure details.

white balance A digital camera control used to balance exposure and color settings for artificial lighting types.

zoom A camera lens with an adjustable focal length, giving, in effect, a range of lenses in one. Drawbacks include a smaller maximum aperture and increased distortion over a prime lens (one with a fixed focal length).

Index

...owledgments and ...ful addresses

...k is dedicated to Sienna

...like to express my thanks to everyone who has made this book possible, especially Marcello Pozzetti, whose excellent work adorns the Sports page. I'd also like to express my gratitude to everyone I've worked with to bring this book about, the editorial team, Tom Mugridge, Kylie Johnston, Stuart Andrews, and Adam Juniper, and designers Chris and Jane Lanaway, Julie Weir, and Les Hunt.

Adobe Photoshop software
www.adobe.com

Alien Skin Photoshop plug-ins
www.alienskin.com

Apple Computer
www.apple.com

Canon
www.canon.com

Corel Photo-Paint, Paint Shop Pro
www.corel.com

DP Review Digital camera reviews
www.dpreview.com

Epson
www.epson.com

Extensis
www.extensis.com

Formac
www.formac.com

Fractal
www.fractal.com

Fujifilm
www.fujifilm.com

Hasselblad
www.hasselblad.se

Hewlett-Packard
www.hp.com

Iomega
www.iomega.com

Kingston (memory)
www.kingston.com

Kodak
www.kodak.com

Konika Minolta
www.konicaminolta.com

LaCie
www.lacie.com

Macromedia (Director)
www.macromedia.com

Microsoft
www.microsoft.com

Nikon
www.nikon.com

Nixvue
www.nixvue.com

Olympus
www.olympusamerica.com

Paint Shop Pro
www.corel.com

Pantone
www.pantone.com

Photographic information site
www.ephotozine.com

Photomatix
www.hdrsoft.com

Qimage Pro
www.ddisoftware.com/qimage/

Ricoh
www.ricoh.com

Samsung
www.samsung.com

Sanyo
www.sanyo.co.jp

Sony
www.sony.com

Symantec
www.symantec.com

Wacom Graphics tablets
www.wacom.com